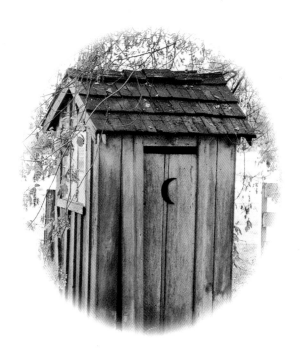

NATURE CALLS

The History, Lore, and Charm of Outhouses

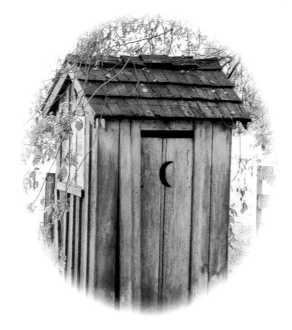

Dottie Booth

Ten Speed Press
Berkeley, California

Ten Speed Press
Post Office Box 7123
Berkeley, California 94707
www.tenspeed.com

Distributed in Australia by Simon & Schuster Australia, in Canada by Ten Speed Press Canada, in New Zealand by Southern Publishers Group, in South Africa by Real Books, in the United Kingdom and Europe by Airlift Books Company, and in Malaysia, Singapore, and Indonesia by Berkeley Books.

Library of Congress Cataloging-in-Publication Data
Booth, Dottie. Nature calls: the history, lore, and charm of outhouses/Dottie Booth.
 p. cm.
ISBN 0-89815-990-3 (alk. paper)
1. United States—Social life and customs—Pictorial works. 2. Outhouses—United States—Pictorial works. 3. Country life—United States—Pictorial works. 4. United States—Social life and customs—Miscellanea. 5. Outhouses—United States—Miscellanea. 6. Country life—United States—Miscellanea. I. Title.
E161.B66 1998 97-50323
973.9'09734—dc21
 CIP

First printing, 1998
Printed in China

5 6 7 8 9 10 - 04 03

This book is lovingly dedicated to my children,
Amy and Douglas Scott, Tia Booth, John Booth,
and Robert and Gretchen Booth;

my grandchildren,
Evan Thomas Scott, Kerry Marie Scott,
and Katie Elizabeth Booth;

as well as all the other unborn little ones
I have yet to meet.

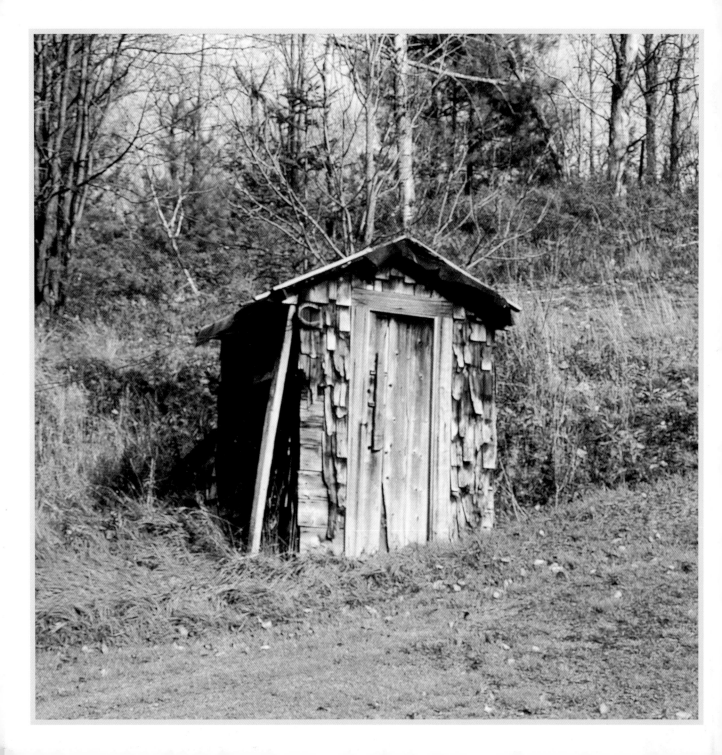

CONTENTS

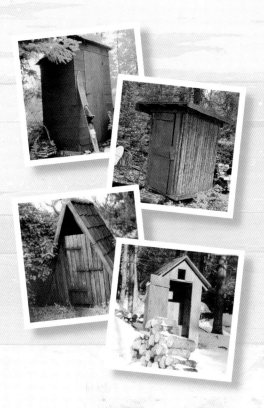

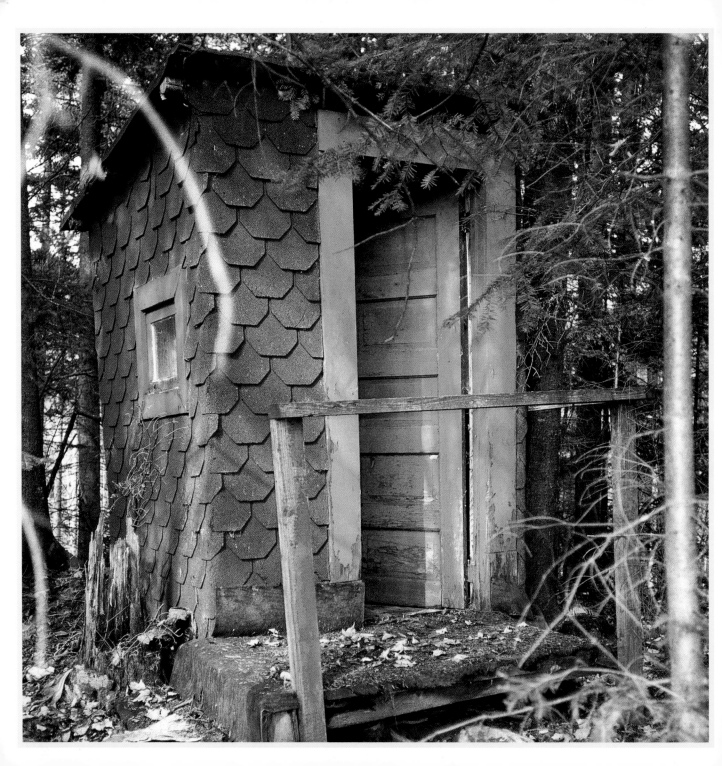

ACKNOWLEDGMENTS

Any writing that involves personal stories as well as the gathering of history requires the cooperation of many willing contributors. I am deeply grateful to everyone who sent me photos and shared stories from their past with me. I have been truly amazed at the number of pictures I have received since I started my business, Nature Calls, almost six years ago. Selecting a limited number of photos for inclusion in this book was extremely difficult. In fact, the competition was so intense that my own outhouse didn't make the book!

The enthusiasm that people have for this subject has impressed me. Wonderful people from all over the country have made me laugh with funny stories and jokes. I was always pleased when someone would say, "I saw an outhouse, and I thought of you." It was even better when they took a picture of it.

In addition to the contributors, I would especially like to thank my wonderful children, Amy and Douglas Scott, Tia Booth, John Booth, and Robert and Gretchen Booth. Their love and support have meant more to me than they will ever know. Their confidence in me often kept me going. For their optimism, pride, and helpfulness in so many ways, I extend my deepest gratitude.

Besides my children, other family members were my always-there support team: sister Lucy Fetterolf and brother-in-law Peter, sister Beth Moss, cousins John and Barbara Adams, and all my nieces and nephews: Peter, Jen, Dave, Erika, John, Janine, Elizabeth, Chris, Cathy, Jim, and Diane.

I thank my very special friends Joyce and Bob Hallman, Les and Sue McCoun, Suzanne Mayer, and Kathy Ford.

I am also indebted to Barbara Sartoris, my invaluable office manager, who handled many responsibilities and kept the business running smoothly when I was working on the book or away on business. She was always understanding.

Lena Bova, my cheerful assistant, willingly tackles whatever needs to be done, whether it be shipping, customer service, or inventory.

Laura Evard, presently in charge of special projects, has enhanced the many different positions she has filled in the company with her creativity and sense of humor. I appreciate her dedication.

Sarah O'Connell, my friend and my doggie's "Nanny," cared for Maddi and my house while I was away. For her advice, help, and concern when I was overburdened, I am very grateful.

Marian and Paul Delisle made my many photo trips in the Adirondacks possible with their hospitality, and their lifelong friendship has always meant a great deal to me.

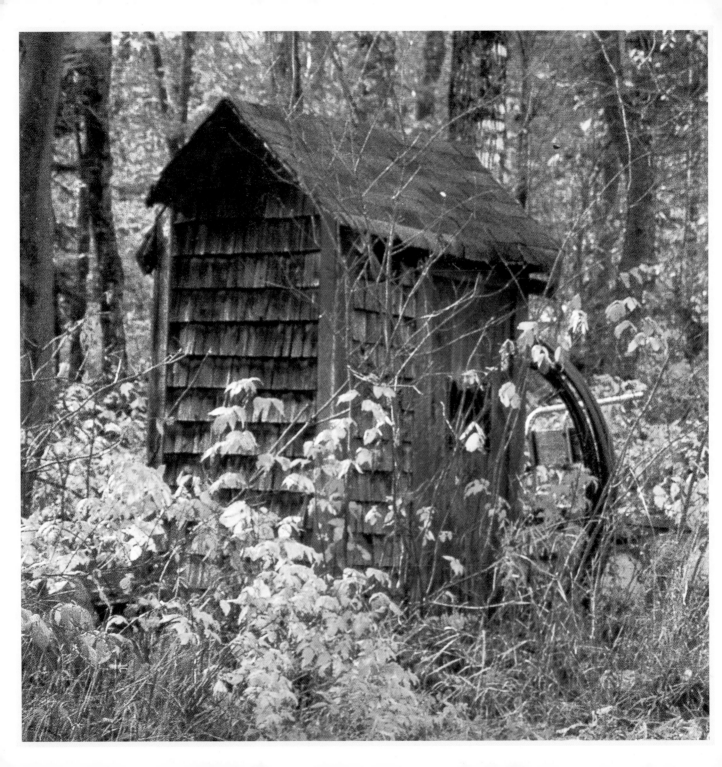

INTRODUCTION

Outhouses are IN. Finally.

There has been a growing movement toward collecting and preserving outhouses and their memorabilia. Everything old IS new again. Too many old privies were being torn down, burned, or used for landfill. Today's young people hardly know anything about these little structures and have no understanding of the lifestyle that went with them.

I began photographing outhouses when I realized that all these original pieces of history would eventually disappear with no proof that they had ever existed. Preservation, in my mind, was imperative.

For years, our family has spent the summer season at our home in the Adirondack Mountains in upstate New York. Initially, I decided to photograph our dilapidated outhouse for the family photo album. I realized it would be gone and the grandchildren would have no idea what an outhouse was. I certainly had no intentions of developing a business!

After photographing a few of my friends' outhouses, I thought that perhaps I could create an exhibit on a wall in the local museum to showcase some of these forlorn-looking yet charming reminders of bygone times. Outhouses were once an important part of everyday life, and their historical contribution should be recorded for posterity.

In 1988, I went on my first photo trip and found fifty-six outhouses still standing. I have done a photo trip every year since then, but the outhouses are harder to find each year. When I had amassed my initial collection of snapshots, I realized that if I put the pictures on notecards to sell in stores, more people would become aware of this vanishing species.

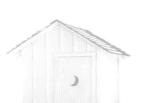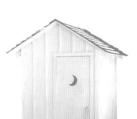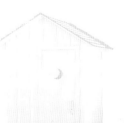

At the same time, I created a poster displaying even more images. A couple of years ago I created a jigsaw puzzle, and now Nature Calls, Ltd., distributes sixteen products, including playing cards, a stencil, earrings, and night-lights. As I took these products to trade shows across the country, national awareness was created and the business grew. It was exciting! Since then, I have gone from being the products development department, the secretary, accountant, shipping department, and head of marketing in a one-woman operation to being the owner of a thriving business with a full-time office manager and three part-time assistants.

Along the way, people have sent me pictures and many have told me stories of outhouse-related adventures and memories. I realized that these tales needed to be shared with a wider audience.

This book should be informational as well as amusing. The outhouse is a fast-disappearing piece of architecture that needs to be explained. Perceptive schoolchildren learning about old houses and mansions during field trips often ask, "Where did the people who lived here go to the bathroom?"

Outhouses that once would have been torn down are now sold to the highest bidder. They are appreciated as valuable collectibles. Sometimes the seat board alone brings a handsome price. Landscape architects are moving these quaint buildings to clients' backyards.

Meanwhile, the outhouse preservation movement is growing. I hope that with help from this book, this architectural misfit will reach its proper place in history. I invite everyone to join in this "celebration of rustic practicality."

PREFACE

Understanding Outhouses

Some people might find it hard to believe that there are those who have never seen an outhouse, much less used one. For folks devoid of the outhouse experience, this general information will be especially helpful.

The outhouse was originally a small structure that would probably fit in some of the closets of today's better homes. There were usually no inside walls, insulation, or decoration. The seat was a bench with a hole in it, and the whole building was set over a pit in the ground. Often, when the pit was almost filled, instead of cleaning it out, the owners would dig a new hole, and the outhouse would then be pushed, shoved, and positioned over the new hole. The dirt from the newly dug hole was spread over the filled pit, and boards were usually laid on top so no one would forget and step into it.

Before the luxury of indoor plumbing, outdoor privies were the rule, and they appeared in all kinds of designs. Because most of the outhouses we find today are really old, it is difficult to know who built them or exactly when they were constructed. Often it is even difficult to determine the present owner.

The Environmental Protection Agency has stated that new outhouses can no longer be built because of seepage of human waste into the ground. Old outhouses can be restored, and decorative outhouses in backyards are acceptable. These are often used for garden tools or storing firewood. An outhouse could possibly house one of the new type of toilets that composts waste into ash. These, however, are quite expensive.

Looking at the pictures in this book, you will notice that outhouses were very diverse in their construction and decor. People used whatever materials were available—in one case, bean poles from a World War II victory garden. There does not seem to be any regional architectural style. Roofs sloping from front to back are found as often as peaked roofs. About half of the outhouses pictured in the book have windows. Some use only the crescent moon for ventilation and light.

Family outhouses were decorated more than public outhouses. People often went to great lengths to make the interior of their private privy as pleasant as possible. Since nature calls everyone, before there was indoor plumbing, people of every religion, color, and social status needed to

use an outhouse. Even in the large cities, there were privies. Of course, one hundred years ago the cities were not like they are today. In the late 1800s, there were still some unpaved roads in New York City, for example.

If you should come across an outhouse today that is padlocked, it is probably storing equipment for owners who have left the area for the winter. In the past, when outhouses were in use every day, it would be unusual for a privy to be locked from the outside.

Much more information is found in the chapter "Frequently Asked Questions," starting on page 25. There are certain things that almost everyone wants to know, such as why the crescent moon shape was carved into outhouses, why people talk about corncob boxes, and so on.

Although outhouse memorabilia can be purchased at craft shows or country stores, one can buy an actual outhouse only from a farmer or someone who still has one standing behind a cabin, hunting camp, or old schoolhouse.

Outhouses can cost from $500 to $4,000. One museum recently paid $6,000 for one. If you are lucky, you can get an outhouse free from someone who just wants to get rid of it. However, finding one at all is the hard part.

I hope you enjoy the diversity of the outhouses on the following pages.

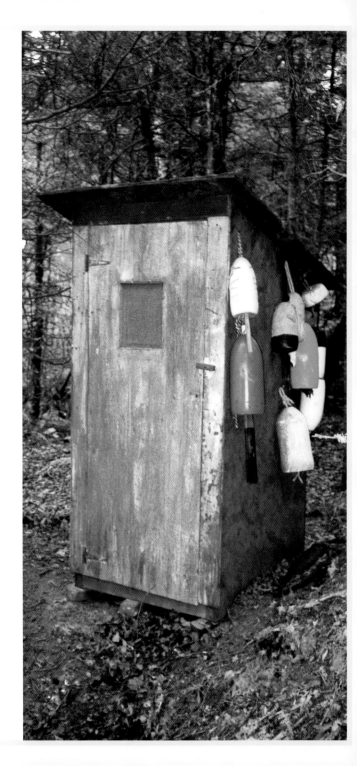

The Potty Poem

The following poem is lovingly dubbed "the potty poem" by the Nature Calls company and its customers. The last two lines of the poem focus on the purpose of the company's existence: preservation. The verses state the reason for the existence of the outhouse ("for times when nature'd call") and emphasize how different each privy is. The author of this popular poem is anonymous.

That Little House in Back

There's been a lot of landmarks
victimized by passing years.
For one, though nearly obsolete,
There's been no rash of tears.
It played its part in history
And was a friend in need
To all mankind both rich and poor
Who did his daily deed.
For an endangered species there
has been a woeful lack,
To save it for posterity—
That little house in the back.

They were alike in some respects,
Yet differed one and all.
Construction didn't matter much
At times when nature'd call.
Though some were fancy, some
 were plain,
Some painted red or white,
All had a well-used beaten trail
That led there day or night.
Though some were open to the wind,
Of privacy a lack,
It served its useful purpose—did
That little house in back.

Now some were built with just one seat,
And others three or four
Of different sizes. Some for kids
Were built close to the floor.
It was a place to smoke or think
Or dream at close of day
While looking through the catalog
At what was on display.
But icy winds of winter that
Would whistle through a crack
Discouraged one to loiter in
That little house in back.

Preserved now in museums you
Will find there on display
The artifacts the pioneers
Used in an early day,
From furniture to farming tools
And rigs for threshing grain,
And shoes of oxen pulling
Covered wagons 'cross the plain,
And logging gear and ancient
Locomotives on the track.
How often have you seen preserved
That little house in back? 🌙

Rules of the Privy

Parking Limit: two minutes on holidays, seven minutes in summer, twelve minutes in winter.

Men: raise seat if not sitting.

Smokers and left-handers sit to the left.

Refill catalog and corncob box when empty.

Do not comment on other occupants' eating habits.

Use only one seat at a time (except on New Year's Eve).

Do not walk on seats.

Not responsible for any newspapers or books left here.

Keep your shoes on.

No drinking or gambling.

Don't shoot animals in privy.

Please observe our four-page limit.

Don't discuss your condition with other occupants.

No fighting.

Waiting must be done outside if full.

Taco, refried beans, sauerkraut, and herring eaters, use neighbors' privy.

Knock once to determine if occupied.

Knock twice for emergency, and if you hear someone running on the path, get out quickly. ☽

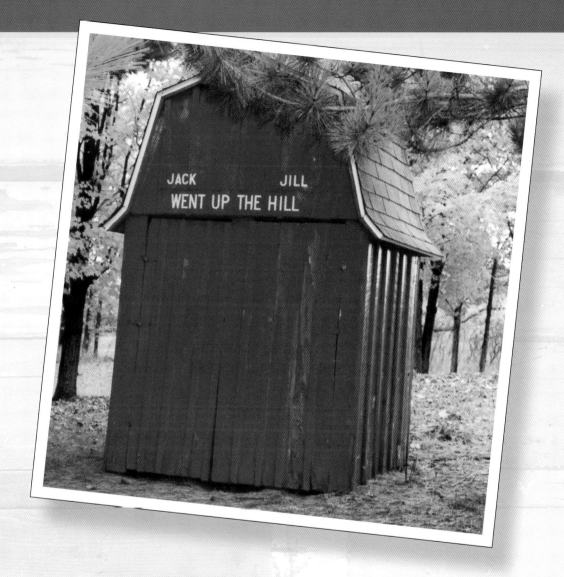

JACK JILL
WENT UP THE HILL

Personal Memories
and Reflections

The stories of real people make the subject of the outhouse a little more understandable to those who have never used one. Friends, relatives, and many others I've met have shared anecdotes with me. Here are a few of their memories and tales, along with some additional information.

Jack Hinman, former principal of the high school in Malone, New York, has a summer camp on nearby Indian Lake. He writes of the painful demise of his outhouse. The feelings of regret he expresses are shared by many who wish they had kept their privies:

When the demolition crew removed the camp next to ours, I asked them to remove our outhouse. I felt great sadness when they fastened a chain around it, pulled it over, and dragged it down the road. It maintained some dignity by not falling apart, and when lifted high on the truck for its last ride, its character showed. If I had to do it over again, I might have painted it with gold paint, and kept it forever! Alas, time marches on.
—Jack Hinman, Malone, N.Y. ☽

While vacationing in Jackson Hole, Wyoming, my husband and son decided to do some whitewater canoeing. As they put the canoes into the river, they asked me to meet them in about two hours at a designated area further downstream. After they disappeared around the first bend of the river, I decided to use an outhouse in the woods nearby before making the drive to the pickup point.

As I closed the door of the outhouse, I heard the latch go down. I realized immediately that I was locked inside. Horror and panic overtook me. I screamed and yelled and banged on the walls. Silence. There was no one around. Trying to stay calm, I evaluated various ways to escape. The window was too small for me to get out that way, and the roof was solidly attached. It was getting hot and I was feeling claustrophobic. The odor was unpleasant. Panic turned to despair, and I sat down and cried. Time passed. If only I had my pocketbook or keys! Was I doomed to die in there? Sitting there dejectedly, I suddenly realized I could unstrap my sandal and possibly slide the strap through the small crack in the door under the latch.

I did this, sliding the strap up very carefully. It lifted the latch! Stepping out into the sunlight and fresh air after having spent most of the morning in captivity, I breathed deeply and congratulated myself on my escape. When I finally got to the pickup point, I was met by two somewhat annoyed people. "Where have you been?" they inquired impatiently.

"Let me tell you where I've been," I responded.

—Phyllis Bennet, Pittsfield, Mass.

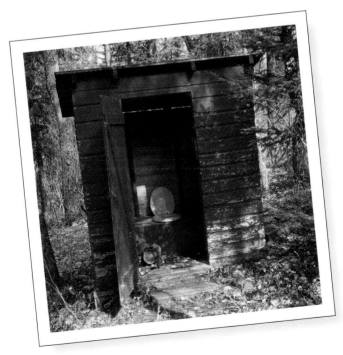

I got my first kiss in an outhouse. The young man asked me if he could kiss me, and I said yes. He did, and I immediately slapped his face. I thought that's what you were supposed to do. I was a naive young girl from Portage, Michigan, and my only knowledge of kissing had come from the movies."

—Lauri Evard, Ambler, Pa.

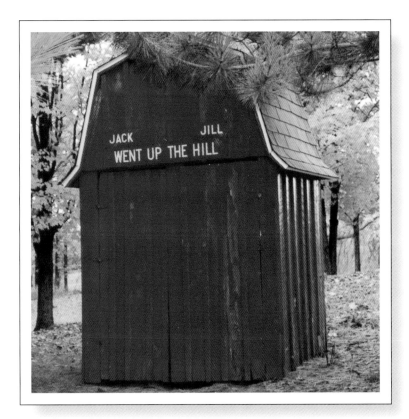

Many tales have been told about how the outhouse was a good place to rendezvous. After all, if "nature called," that was a good reason to get out of the house. Meeting *behind* the outhouse was the usual procedure if it was dark. In the above story, the young people ducked into the outhouse quickly so they couldn't be seen in broad daylight. The outhouse was not a place where you would want to linger too long! (This "Jack and Jill" outhouse is probably a two-holer, because it is larger than most.)

My grandfather was bitten by a rat as he sat in our outhouse in the barn.

 —Marian Delisle, Malone, N.Y. 🌙

On farms the outhouse is usually attached to the barn. This was practical, especially in bad weather. This barn in upstate New York is a typical example.

The roof of this outhouse appears dilapidated, but the outhouse is probably no longer in use. When an outhouse was attached to a barn, there may have been a door from the outside. However, the only entrance was usually from the barn. One of the drawbacks to this arrangement is the increased probability of rodents sharing the environment with you.

Frequently, animals, rodents, and bugs would get into the outhouse. It was wise to keep a lid over the hole and the door closed. In the summertime, flies were especially prevalent. Here are two memories on the subject:

I was stung on my butt by a bee when I pulled down my pants in an outhouse. I'll never forget that.

 —Patsy (told to the author at a wedding reception) 🌙

One dark night I was in the outhouse and I had the feeling someone was watching me. When I went back to the house, I told my husband, so he got his flashlight and went out to look around. Sure enough, there was a big raccoon!

 —Betty (told to the author at a trade show) 🌙

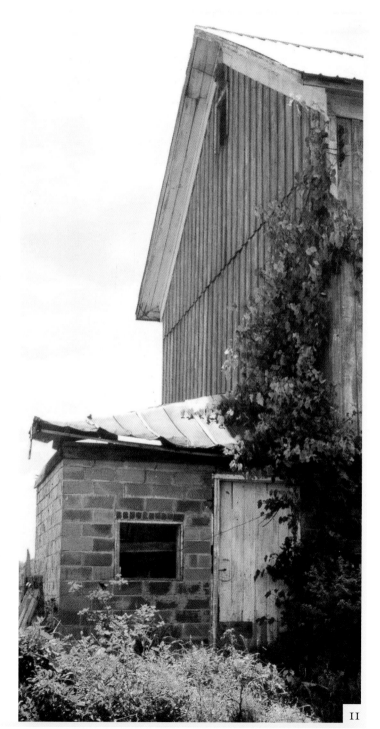

Although the outhouse below looks brownish in color, the owners call it "Black Potty." Since the photo showing the interior appears to be a different color, we can only assume that the exterior was painted again after the photo of the interior was taken. Painting outhouses frequently is necessary because of harsh winters, which cause weathering of the wood. The other interesting feature of this outhouse is the red blocks, which are for comfort for different lengths of legs. A shorter person would sit on the right so that their legs would not dangle.

This is what the proud owners say about their privy:

We feel that no outhouse quite compares with our own at our camp at the far end of Long Lake. "Black Potty," our outhouse, has several unique and commendable features which are readily apparent in these pictures. First of all, its location in a grove of white birch is splendidly uplifting. The view through gentle woods with a glimpse of the lake beyond is marvelous. Finally, it's a real family place, a genuine two-seater. This last point is especially important to us all.

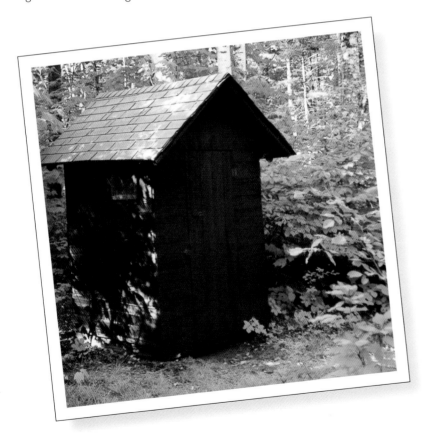

We have twin sons who have worked through many an argument seated à deux. Also, my husband and I, the parents of said twins (and a two-year-old as well), sometimes find that communing in the Black Potty is the only peace we get in a hectic summer day!

The outhouse was built in 1940, when the camp was built. It has been in use ever since, despite the fact that we now have a bathroom in the cabin (added in the '70s), which we all hate to use. Most importantly, and we plan to have this added to our camp stationery someday, we have what Susan's mother calls "the sweetest smelling outhouse in these contiguous states."

Our pride is tremendous. If you're ever in the neighborhood, do drop in. Two holes, no waiting!

—Susan and Peter Hackett, Long Lake, N.Y. ☽

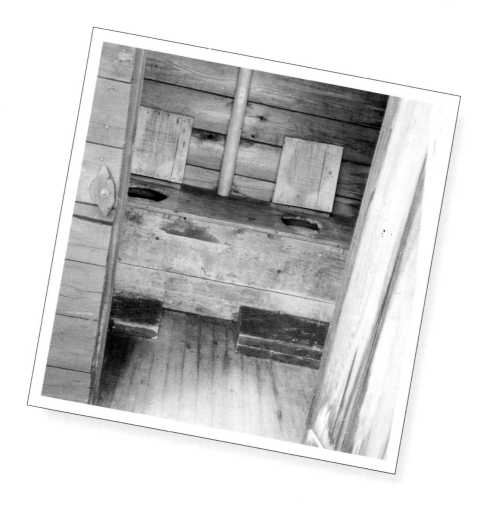

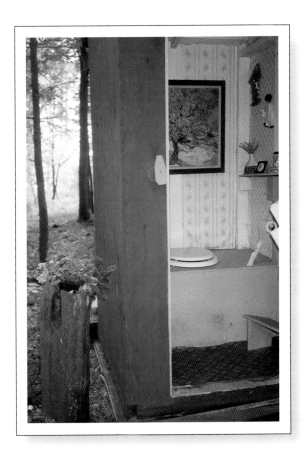

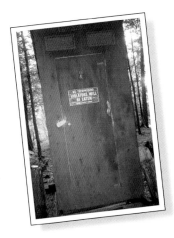

The interiors of outhouses were as different as the owners. Residential privies were routinely cleaned, and they housed a variety of practical accessories. Some of these items might include a flyswatter, a bag of mothballs hung up to keep mice away, and a bucket of lime for throwing a scoop or two down the hole after use. Wall decor often consisted of magazine covers—especially the *Saturday Evening Post*—and colorful prints tacked up on the walls. Some outhouses even had wallpaper.

Other accessories often included were insect spray, fragrance spray, a toilet paper holder (or corncob box!), and sometimes a step stool for children. A nice touch was a piece of carpet on the floor, as seen in the photograph of "Patsy's Palace," at left.

Some people put toilet seats over the holes. Most people had lids for the holes; some had a hinged seat cover for each hole. Some upscale privies, such as George Washington's at Mount Vernon, had beautifully polished mahogany seats.

Outhouses behind camps and hunting lodges were usually much more rustic and unadorned, like "Black Potty" (page 13).

Privies in upscale country resorts were scrubbed and redecorated before paying guests arrived for summer. Years ago, clean facilities were as important to tourists as they are today.

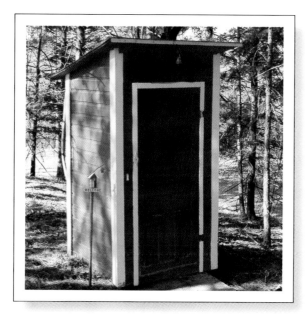

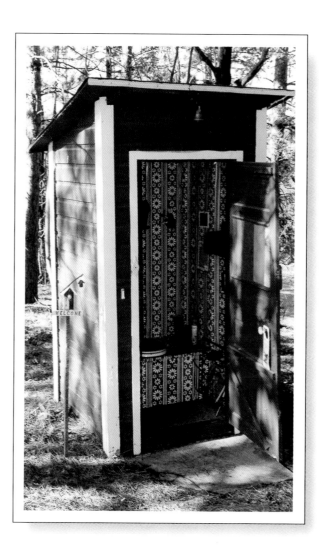

I was on a hayride with a group of friends in college. We had a keg of beer on the wagon, and evidently the farmer driving the wagon had had as much beer as us students. In his inebriated state, he ran over someone's outhouse.

The state police were summoned, but of course, in those days, there were no citations for driving under the influence. The farmer was ordered to take up a collection from us to buy the owner a new outhouse.

—"Uncle Bob" Booth, Doylestown, Pa.

My father, Guy E. Allison, went to the Mayflower one-room school in Iowa. The distance from the school to my Grandma Allison's farm via the road must have been three or four miles. However, if you cut down the hill, crossed the creek at the bottom, and went up the opposite hill, the distance could be reduced to about a mile and a half.

When my dad was young and had to go to the privy, he couldn't button up the flap in the seat of his long johns. He wouldn't let the teacher do it, so he would run all the way home so that his Ma could fasten his drawers.

—Homer Allison, Bryans Road, Md.

My daddy had lots of fruit trees on his 800-acre farm near Johnstown, Pennsylvania. However, when we were young, my friends and I used to slip over the fence and steal pears and apples from the neighboring farmer's trees.

One day during our foray into the neighbor's orchard, the old gentleman caught us red-handed and promptly turned us over to our dads, whose disciplinary action was swift. We were mad and vowed to get even.

Now, the railroad ran between the two farms. The trains would stop at the water tower at the edge of town, and take on a load of water every day. The neighbor's privy was situated between the house and the orchard, next to the railroad tracks. One day my friends and I sneaked over to the neighbor's farm and tied a heavy-duty rope around his outhouse. We connected the other end of the rope to the caboose of the train while it was stopped to take on its daily load of water.

The rest is local history. Old-timers still talk about the day the freight train pulled into town dragging a full-size two-hole outhouse.

—Story told to Homer Allison by a friend

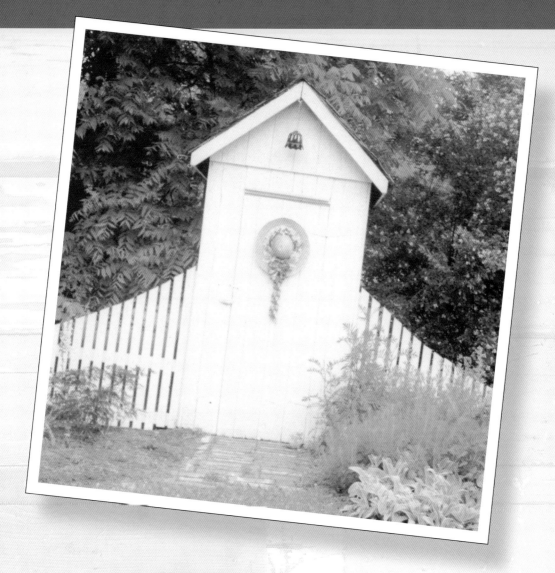

Nature Calls
Around the Country

The old "backhouse" has been well repre- sented in all sections of the United States over the years, and, in the following pages, you will see samples of great geographical diversity.

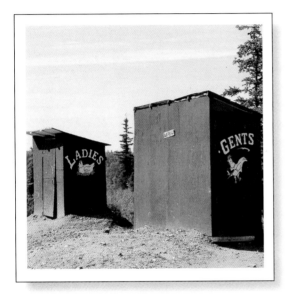

Chicken, Alaska

The ladies' and gents' facilities shown here are in the very rural town of Chicken, Alaska. Chicken is located halfway between Fairbanks and Dawson City. Apparently this is the total sanitary system for Chicken. These outhouses are larger than ones you would find on a farm because they were made for the public.

People often tack signs on outhouses, and the numbers on the gents' outhouse most likely have no significance. The important thing to notice would be the pictures on the sides. The rooster and hen may have been put there for people who could not read, or they could be merely a humorous touch.

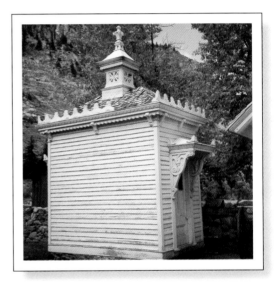

Georgetown, Colo.

This is a beautifully ornate outhouse with a cupolaed roof and gingerbread trim. It has three solid walnut seats of assorted sizes, which were reserved for family members. Servants used the back door of the privy, which led to a pine plank seat. The mining baron W. A. Hamill built this outhouse in 1879.

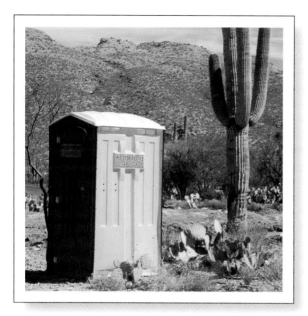

Tucson, Ariz.

This picture was taken in Tucson, Arizona, at the brand-new Raven Golf Course. This outhouse was used by the course workmen. Although it is not old, the reason for its existence is the same as that of privies built one hundred years ago. Some "modern" outhouses like this one are known as port-a-potties and are very colorful and clean. Judging from the sign on the door, this outhouse could be a pit stop for golfers.

Woodstock, Ill.

This is a midwestern outhouse in Woodstock, Illinois. Although the trim appears newly painted and the potted flowers are colorful, the paint is peeling on the sides and restoration seems imminent. The door is padlocked to keep out animals, vandals, or thieves. Most likely, the lawn mower is now stored in there.

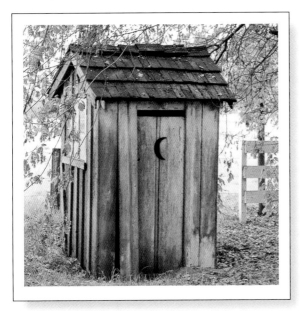

Built in the mid-1800s, this "his" and "hers" set of outhouses is located in an early settlement of the Okefenokee National Wildlife Region in Florida. Note the crescent moon that appears on the women's door but not on the men's.

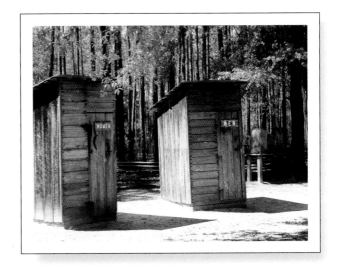

Chualar, Calif.

The Chualar Canyon outhouse shown here is in the town of Chualar, California. It sits in a meadow behind an old ranch house. Note the 3' x 2' paned window, crescent ventilation system, and double-pitched shake roof. The gap at the top of the door is for ventilation and light.

There was a crooked
man who walked a
crooked mile to a
crooked outhouse!
Can you imagine
using this one? It's
in eastern Vermont,
near Charlotte.
I think the builder
of this one was
having a lot of fun!

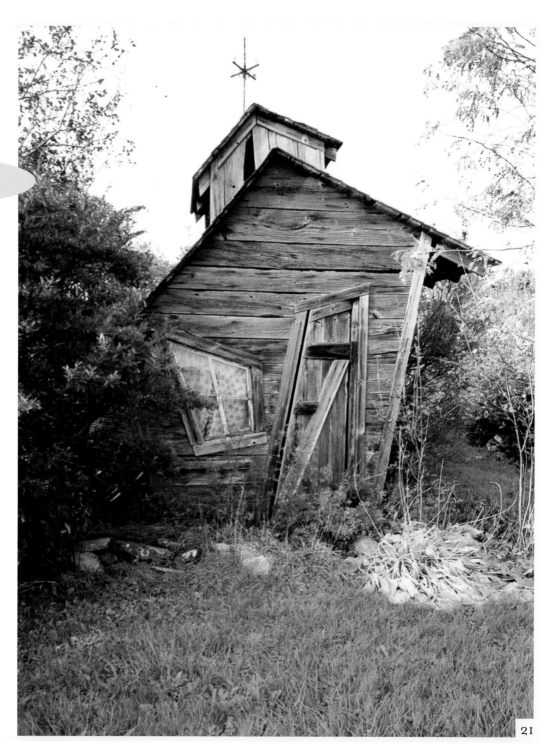

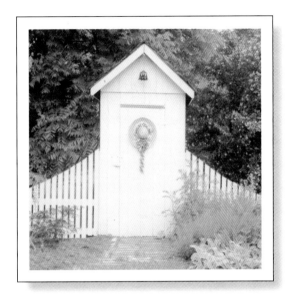

Harleysville, Pa.

This outhouse is behind a very old farmhouse in Harleysville, Pennsylvania. When the owners restored the farmhouse, they decided they should restore the outhouse, too. They moved it closer to the house, put up a fence, and planted an herb garden in front. At Christmastime they decorate it as they do their home. Charming.

Mountain View, N.Y.

In northern Mountain View, New York, this outhouse is set away from a large A-frame house built and painted in similar style. The red door of the larger building proclaims, "The Erry Inn." The outhouse, of course, is "The Erry Out."

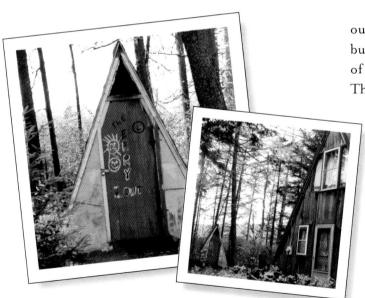

42,000 outhouses

A 1990 study concluded that more outhouses are in regular use in North Carolina than in any other state. No one really knows exactly how many there are, but according to 1990 U.S. Census data, about 42,000 year-round housing units lack complete indoor plumbing.

David Holdfield, professor of history at the University of North Carolina in Charlotte, says, "We have two states in North Carolina: metropolitan North Carolina and rural North Carolina. It's a third-world country."

Governor Jim Hunt has announced a $1 million program to install indoor plumbing in the homes that need it most desperately. However, that much money will help only fifty of them, at an average cost of $20,000 per home. Pam Wilson of the Division of Community Assistance says, "If you don't have indoor plumbing, you have to build a bathroom."

While North Carolina leaders and rural-development advocates want to knock down all these old outhouses, others quietly wonder if a powerful piece of Southern history could be lost forever.

The matter of health issues versus history and nostalgia is still being debated.

All Tricks, No Treats

Throughout the country, Halloween is the time of year for mischief with outhouses. Every privy in the country is in grave peril. Many are tipped over, moved, or torched; indeed, everyone seems to have a story about privy "tricks." Here are samplings from various pranksters.

Some high school students in Lake George, New York, stole an outhouse and placed it on the roof of the high school. No one knew how they got it up there, nor did anyone know how to get it down. Since no one admitted to the prank, the privy remained there for many days. People still talk about how ridiculous the school looked, but no one remembers who got the privy down.

One Halloween, a man and his friends in Inlet, New York, stole numerous outhouses and set up a whole "village" on the town green. It was hilarious—until they had to remove them all.

One former student at Clarkson University in Potsdam, New York, recalls how he and some of his fraternity brothers put an outhouse on the dean's front lawn. Imagine his surprise. The culprits were never found out.

Sue, from Old Forge, New York, was not so lucky. One Halloween night, she and her friends stole an outhouse from Hawkinsville. They hauled it on one boy's truck two miles to Booneville. There they set it up in the park, doused it with kerosene, and torched it.

When the fire department arrived, they crawled on their bellies across the park to escape unseen. When they emerged from the park, the constable was sitting in his car with his headlights off, waiting for them. Since the constable and Sue's father were well acquainted, he drove Sue home to a strong reprimand, and the fun of the prank fizzled. Sue explained to her parents that the stolen outhouse was just one of two from a go-cart track. In her defense, she exclaimed, "We only took *one*!"

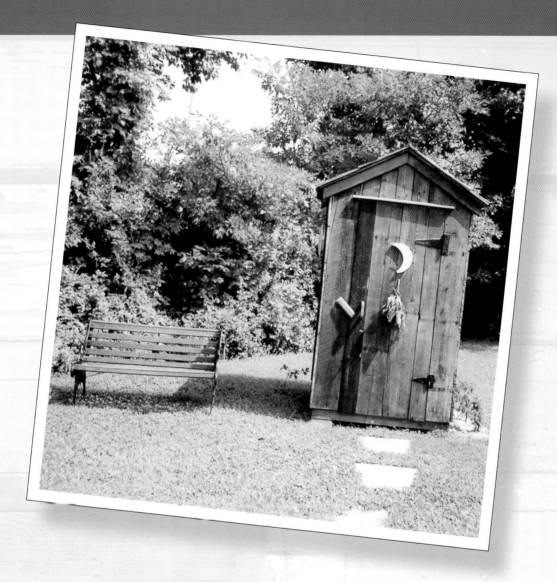

Frequently Asked Questions

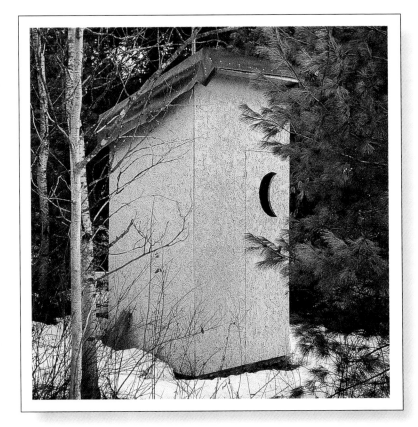

write, these symbols were necessary. Folklore also tells us that the ladies took better care of their outhouses, so that is why the moon symbol prevailed and appears on most outhouses today.

One reason women's outhouses outlasted men's may be that porcupines gnawed on the seats of the men's. When you consider the fact that men stand and women sit in the outhouse, you realize there may have been more urine around the seat in a man's privy. Porcupines like salt, which is plentiful in urine. Some people would hang a tire that had salt on it near the house, in the hope that porcupines would chew on that and leave the privy alone.

Some people do not agree with the above sun and moon explanation. They claim that many people had only one outhouse and that the crescent moon solely served as a source of air and sunlight in a room without a real window. There are no vents in colder climates, because even the smallest crack would admit a freezing blanket of snow. Therefore, you will not see crescent moons in some northern areas.

Why the crescent moon?

This is the question most often asked about outhouses.

Luna, the crescent-shaped figure, is an ancient symbol for womankind, and a crescent moon sawed into a privy door became the sign for the "ladies' room." A sun pattern was sometimes cut into the "men's room." A century ago, when only a fraction of the population could read or

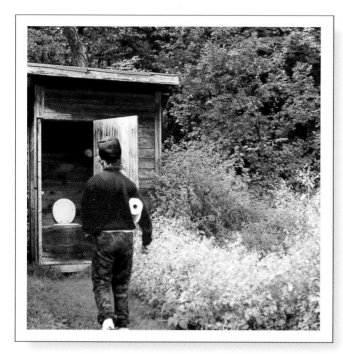

What did people use before toilet paper?

In days of old
When knights were bold
and paper wasn't invented
They used blades of grass
to wipe their arse
And went away contented.
—from *Cotswald Privies* by Mollie Harris

Before toilet paper was the hygienic norm, a wide variety of soft paper products, such as dress patterns, newspapers, and other uncoated paper stock, were used. In the late 1880s, mail-order catalogs were favored because the pages were very soft. By the early 1930s, most mail-order catalogs and magazines had changed over to slick, clay-coated pages, so catalogs fell into disuse as a toilet paper substitute.

Toilet paper is a fairly modern invention. In the early 1880s, an Englishman named Walter J. Alcock patented the perforated product. Very aggressive and persistent marketing was needed, however, to convince Victorians that this product should be sold publicly. By the late 1880s, toilet paper fixtures (roll holders) were carried in most hardware stores. Toilet paper could be ordered from Sears, Ward & Co. at $1.00 for ten packages.

Before paper of any kind was available, people used corncobs. There were two kinds: red and white. It is said that a red cob was used first and then a white one. If the white one was not clean, another red one was needed. If there were no corncobs, some people used rags, but most grabbed whatever was at hand. The cobs were kept in a box in the outhouse, and some of these boxes are still found today. Even after paper was in widespread use, families wishing to be frugal still used corncobs.

The young man in the picture is replacing the paper that is always kept in the outhouse. One does not need to bring a roll for each visit!

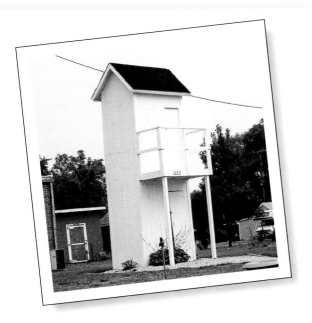

Why were there two-story outhouses?

Think about this: three feet of snow, or a five-foot drift How do you open the outhouse door? Two-story privies like this one were often built for stormy weather conditions. The second-story holes, however, were located further back than the first-floor holes!

This double-decker outhouse in Gays, Illinois, attracts numerous tourists. Evidently this privy, named "Double Doody," made of pine in 1872, draws visitors from all over the country. According to Nancy Goodwin, a member of Gay's village board, F. F. Hammill built this outhouse about ten feet behind his general store. The family apartments were on the second floor of the store. Nancy explains, "It was a long walk to go downstairs and down the path to the outhouse every time nature called, so Mr. Hammill built a ramp to connect the second floor of the outhouse to the apartments above the store."

Today the ramp is no longer there and the outhouse stands alone, but the history of this outhouse proves that convenience, not only bad weather, prompted the building of two-story privies.

What happens when privies fill up?

Privies are cleaned once or twice a year, depending on the size of the family. In the past, a man would come to town with a horse-drawn vehicle that had a big steel barrel-shaped container on the back, into which the contents of the privies were emptied. He would ladle out the contents of the privy with what looked like a very big spoon on the end of a long pole. This was known as the "shittus scoop," and it aided in this not-so-pleasant task. The job, however, was very lucrative for the men who did it.

In London, "Gongfermers" was the name given to those employed to remove outhouse contents. Gongfermers employed the services of apprentices, usually small boys whose unpleasant task was to handle the horse and cart and to rake the privy contents evenly to ensure a full load. Eventually the horse and cart would be driven to the nearest outlet of the Thames, and the entire contents were thrown into the river.

In more rural areas, when the privy was full, sometimes they would just dig a new pit and move the whole outhouse to the new location. Naturally the old pit would then be filled in!

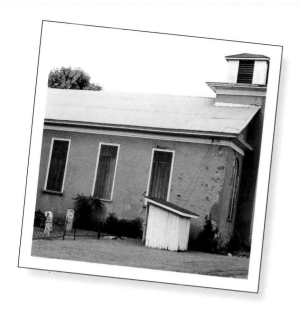

Did all public places have outhouses?

Absolutely! Churches, schools, train stations, and country stores all had conveniently located privies.

The following story comes from Homer Allison, outhouse aficionado from Maryland:

On a hot day when the windows were open in the church, a couple of us young lads would pretend like nature called and leave the service one at a time for a few minutes. We'd go out and take a long pole we'd hidden nearby and stir up the shit in the outhouse.

The pastor used to keep his sermons real short on those Sundays.

We used the same trick at school. Sometimes the teacher would dismiss us for the rest of the day!

This outhouse along the railway tracks in Cromwell, Connecticut, is something of a town landmark. Over one hundred years old, the outhouse was used by passengers waiting for the train to Hartford or the trolley to Middletown. Since passenger train service through Cromwell ended in 1948, and the trolley stopped running in 1930, this privy hasn't had significant public use in more than forty years.

The depot is believed to have been built in 1881; the privy was constructed about the same time. The owner, Glen Johnson, a local real-estate agent, restored the wood structure in 1978. Johnson's office is in the former freight depot of the Old Connecticut Valley Railroad line. His wife's new gift shop, the Kit'n Caboose, is also there. It is painted brown with yellow trim, the same colors used by the railroad.

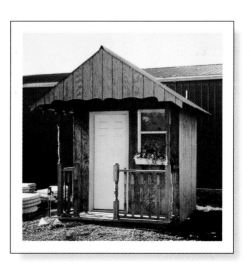

Who was Chic Sale?

When conversation turns to outhouses, the one thing people seem to know about is Charles "Chic" Sale and *The Specialist*. This thirty-two-page booklet is the comical story of a privy builder, Lem Putt, in Illinois. Lem explains how to go about this specialized trade. In print since 1929, this very thin booklet led all bestsellers when it first came out, and has sold over two-and-a-half million copies to date.

Chic Sale was a stage actor and comedian who specialized in dramatizing the building problems of a rural carpenter. He had a wonderful time making people laugh and finally decided he needed to copyright his gags, so he formed The Specialist Publishing Company. The rest is history. The name "Chic Sale" became synonymous with outhouses. People would write to him and ask, "Where should we put our 'Chic Sale'?" Charlie didn't exactly like that, but he always conscientiously answered their letters. He also wrote a sequel to *The Specialist*, titled *I'll Tell You Why*. Both of these books are available for five dollars from The Specialist Publishing Company, 109 La Mesa Drive, Burlingame, California 94010.

The fictional Lem Putt always had very strong opinions about the architecture, placement, and construction of outhouses. For example, should the door open in or out? Lem thought it should open in! Here's why: You could get air and light, but more importantly, if you heard someone coming, you could give the door a quick shove with your foot!

Lem also recommends that the path from the house to the outhouse go by the woodpile. He says that the average woman will make four or five trips a day to the outhouse. On her way back, she'll grab five pieces of wood. That's about twenty pieces in the wood box without any trouble!

The name of this outhouse is "Quartito," which means little room. It is on Indian Lake in Owls Head, New York.

Why were there two-holers?

Today, most homes have at least 2.5 bathrooms, but in former times, there would only be one privy per family. If nature called two people at the same time, both of them could be accommodated. It was not awkward or unusual for friends or family members to share a privy. In fact, there were often benefits to sitting *à deux*, as explained by the owners of the "Black Potty" (pictured on pages 12–13). The outhouse below is a three-holer in Newport, New Jersey.

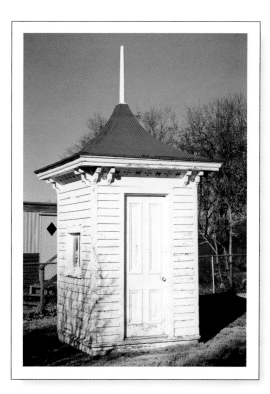

At hotels or inns accommodating many guests, many holes were needed. Very large families also needed multiple holes. Five- and six-holers still exist in various parts of the country. I remember sitting on the porch as a very young girl at our lake house. My father would say, "Who's ready to go up the hill?" I always was, because I didn't want to walk through the woods alone. We had a two-holer, so we would sit down together, look out the open door at the woods, and have a pleasant conversation. Attitudes about privacy were different then.

Large multi-holers were also common on farms. All the farmhands would be brought in at the same time for lunch, and all of them could be accommodated.

What was a slop jar?

The slop jar is another name for the chamber pot. Before houses had indoor toilets, the chamber pot spared its owner from a nighttime trip to the outhouse. The chamber pot was ordinarily kept under the bed or in a bedroom closet, and in the morning it would be emptied. Often it would sit outside, sunning itself until bedtime. Anyone who has traveled a cold, dark, or wet path to an outhouse will agree that the slop jar has its merit. A chamber pot has a lid, and today it is hard to find a pot with the lid intact. They are very collectible.

More Frequently
Asked Questions

Why were so many privies painted white?
The white paint was a navigational aid to nighttime visitors.

Why were most outhouses made of wood?
Wood was readily available and inexpensive. Furthermore, a wooden outhouse,
unlike one made of brick, could be moved fairly easily when a new pit was required.

Why were privies placed so far from the house?
Privy placement was not a random act. First, the owner would try to avoid contaminating
the water supply. Also, placing the outhouse at a distance from the house reduced offensive
odors, especially a problem in warm weather when the windows were open.

Here is a great definition
of an outhouse:

As one man said, an outhouse is "a little house behind a big house,

about 100 yards away. In wintertime, it's 100 yards too far.

In the summertime, it's 100 yards too close."

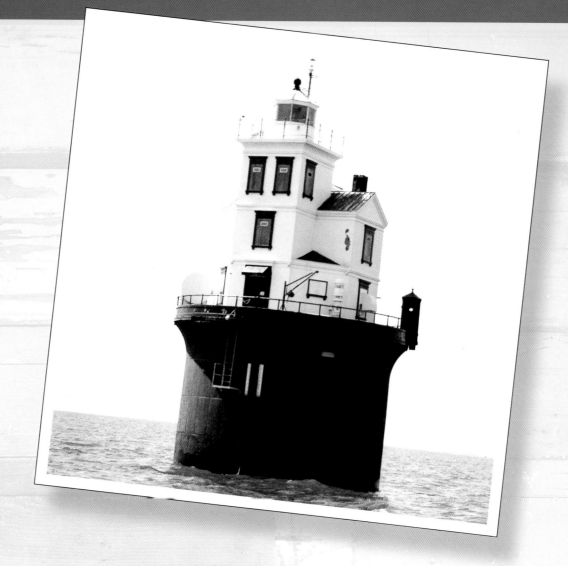

Unusual
Outhouses

Have privy, will travel!

Here we have on exhibit the old-time version of a mobile home. Photographed in Colorado, this outhouse is a wonderful example of how traveling was done in days gone by. The old laundry tub, clothesline, and the lantern on the privy reveal how washing was taken care of. The sign that says "Branson Mall" is surely a touch of humor added for modern viewers.

Bay, on the western side of the shipping canal. When nature called at sea, the lighthouse keeper visited this outhouse.

The Victorian structure, first lit on December 1, 1886, was originally brown. Sometime during the 1930s, the entire cast-iron structure, including the "hip-roof" privy, was painted white with black trim. It remains the same today.

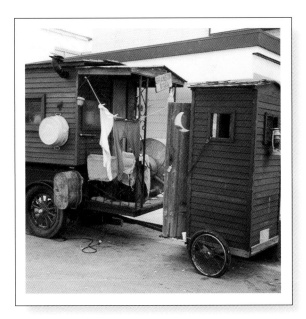

The Fourteen Foot Bank Lighthouse is distinguished by its outhouse, which hangs vertically over the edge of the lowest gallery. The lighthouse is located in the lower part of Delaware

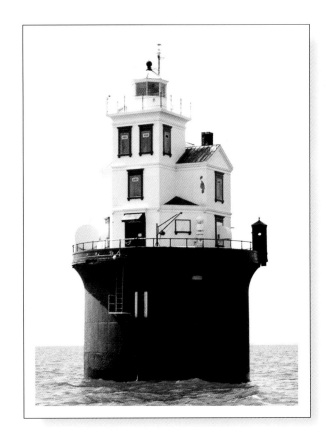

An elaborate two-
story outhouse in
a small mining town
in Wisconsin.

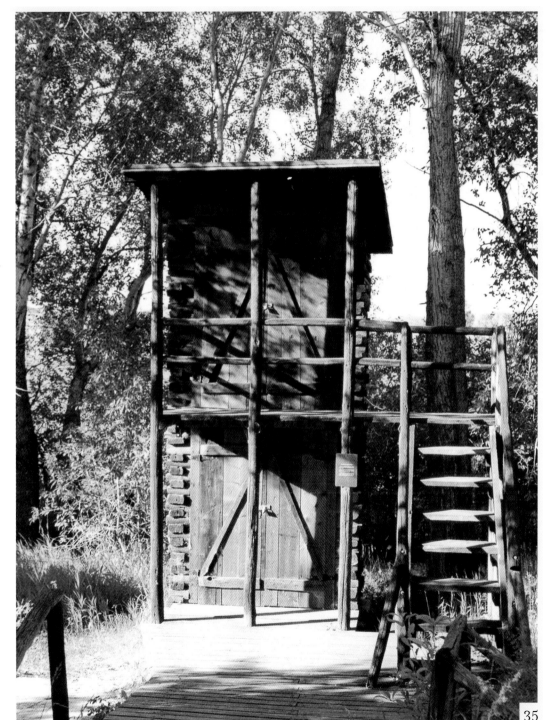

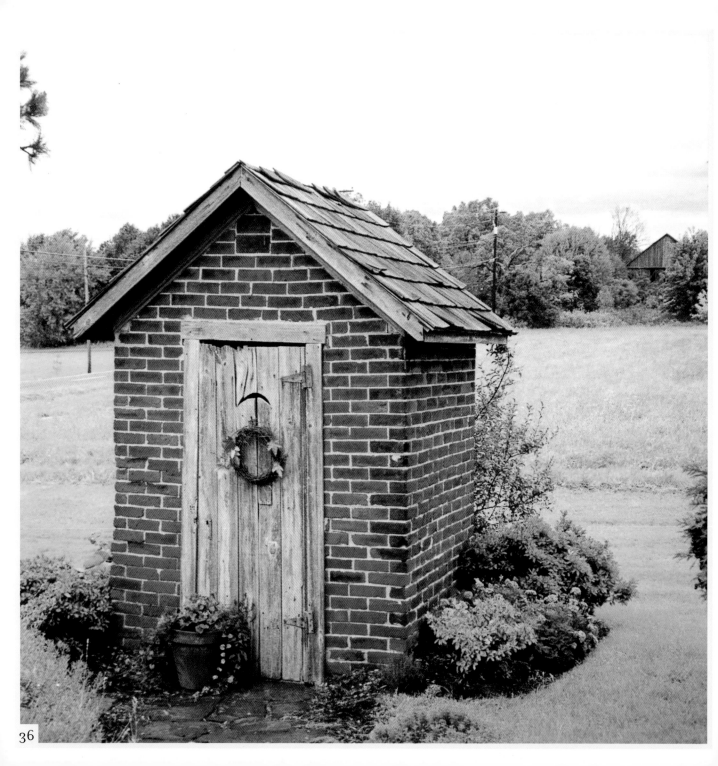

The schoolhouse outhouse

Perhaps this is where we get the expression "built like a brick shithouse." It's solid and square, but very, very charming.

This outhouse behind the Gehman Schoolhouse antique store in Silverdale, Pennsylvania, is a privy palace. Built around 1900, it has been lovingly preserved. The grounds that it adorns recently won the local chamber of commerce award for best business garden. Originally the school had two outhouses, one for boys and one for girls. Today, there is only one privy, and the owner of the store keeps gardening supplies in it. Many outhouse owners store pool supplies, barbecue equipment, or tools in their privies. This one is always decorated in accordance with the season, here showing the colors and flowers of autumn.

A brand-new $800,000 outhouse

The most expensive outhouse ever built exists in the Delaware Water Gap National Recreational Area in Pennsylvania. This new two-holer, which opened in May 1996, cost the National Park Service $800,000. More than a dozen designers, architects, and engineers spent two years designing it. The bill for one Park Service engineer from Denver to live on-site for ten months was $81,220.

The beautiful structure, surrounded by evergreens and specially selected wildflowers, was built on a handsome cobblestone masonry foundation that is earthquake resistant. The privy has cottage-style porches, a gabled slate roof, and one-inch cedar siding, but no running water.

The interior boasts two state-of-the-art composting toilets, which cost $13,000 each. A composting toilet uses no water or chemicals, and there is no odor. Compost is created when human waste and toilet paper are broken down by microbes. Everything is decomposed into ash. These low-maintenance privies are meant to last fifty years or more.

In addition to the toilets, inside each spacious restroom, a green horizontal stripe at baseboard level complements the green of the hemlocks visible through carefully placed picture windows. The place smells as sweet as the woods!

Talk about a room with a view!

These outhouses are found at Acoma Pueblo's Sky City near Albuquerque, New Mexico. Perched all around the edge of the mesa on which the pueblo sits, these outhouses afford an opportunity to step back in time. According to folklore, each Native American chief had his own outhouse. When he was no longer chief, his outhouse would be left alone and a new one would be built for the new chief. This collection of Native American chief's outhouses is part of the oldest continuously occupied city in the United States. Because these outhouses have not been preserved, they will eventually topple over, as the one at left, or collapse from weathering.

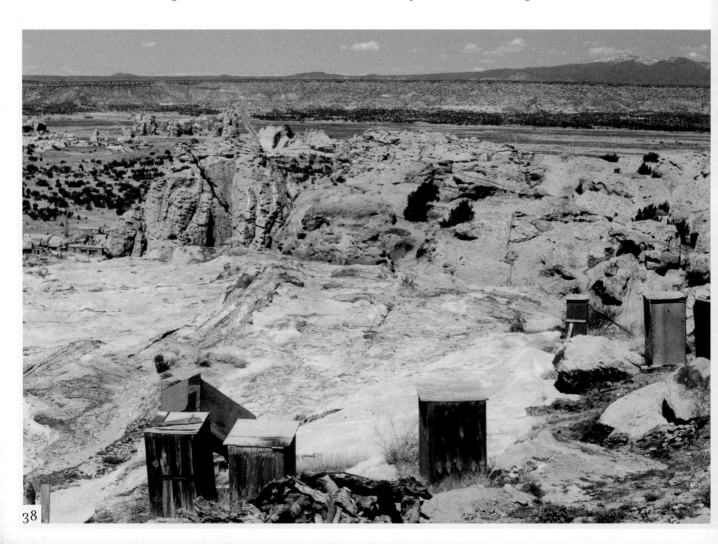

Nature Calls
Around the World

These outhouses reveal certain characteristics of their countries, and indicate how the building materials available there are utilized.

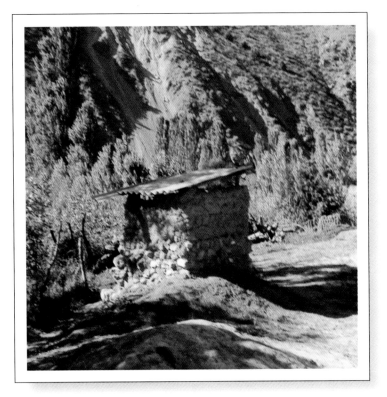

This outhouse is near the Aksu Valley in the Pamiro-Alai mountain range. Once part of the Soviet Union and now an independent state, Kyrgyzstan has been called the Nepal of central Asia. Beneath granite peaks in flowering pastures, nomads have watched over their grazing flocks here since the days of the ancient Silk Road. This outhouse is near that ancient road, which has served as a path from China to the West since the first century B.C. Today this beautiful land of towering peaks and green valleys is a mecca for alpinists worldwide.

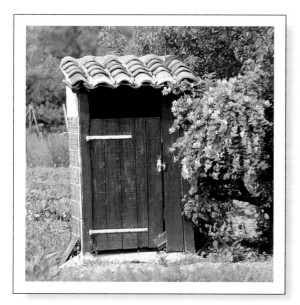

France

The curvy orange tile roof on this outhouse recalls the style of the country houses nearby. This outhouse has several practical innovations. The small door on the bottom left side, ajar in the photo, is an aid in cleaning out the outhouse. The small red flag in the ground by the door can be placed in front of the door to notify others that the privy is occupied. The honeysuckle here is typical of the sweet-smelling bushes and flowering trees traditionally planted near privies.

Sikkim, India

While trekking in the Himalayas, the photographer of this picture was delighted to find this rest stop high above the tree line. When an outhouse is on rocks, it must be strategically placed, since a pit can't be dug.

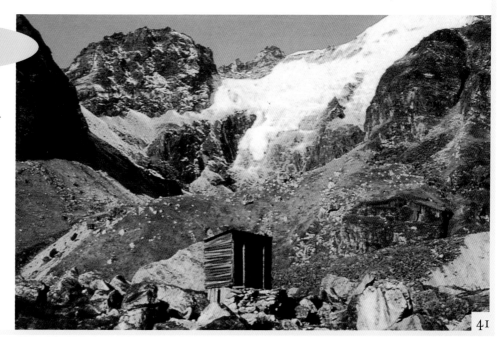

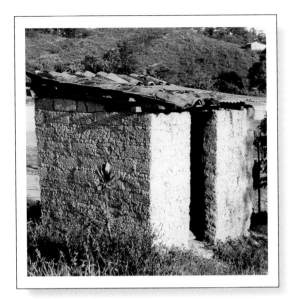

This adobe outhouse is typical of privies in this part of the world. The floor is clay and there are no fancy features here. Adobe has the advantage of being warm in winter and cool in summer.

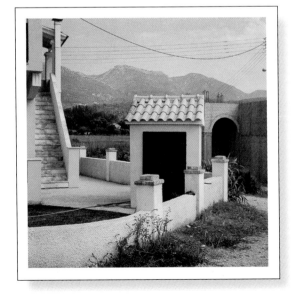

Greece

Unlike the Central American privy, this structure looks like it could be the gatehouse of a marvelous estate. The photographer can verify, however, that this little building is indeed an outhouse, because she used it. The tile roof construction is native to the area.

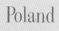

This beautiful wooden A-frame privy is located on a farm in Poland. Years ago, outhouses on farms were as common in Poland as they were in America.

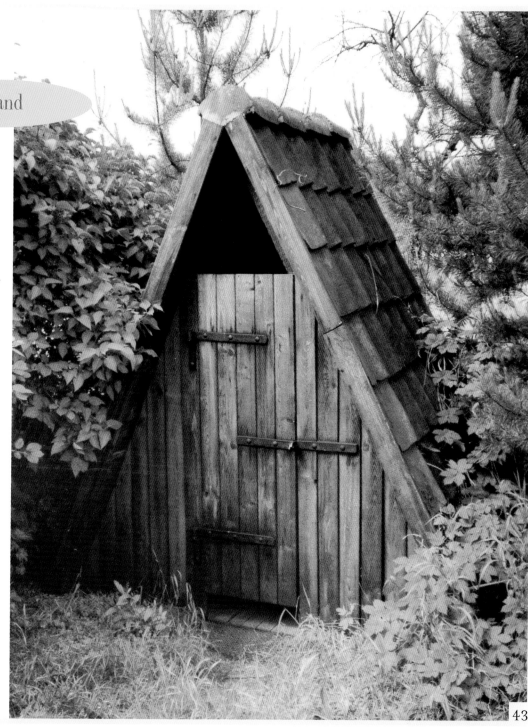

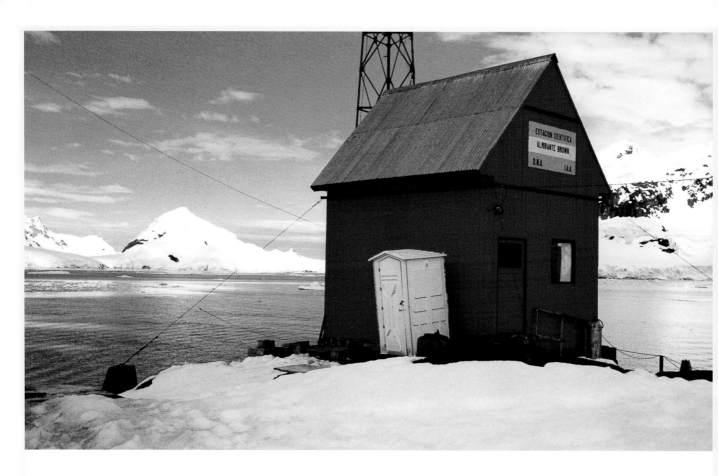

Antarctica

This small white outhouse is adjacent to the
Argentine ranger station. It's not exactly the *hot* seat!

The Yukon

This poor weather-beaten structure was spotted 125 miles from the Arctic Circle in early June. It probably was not yet open for the season. Do you think the board against the door would really keep out a bear?

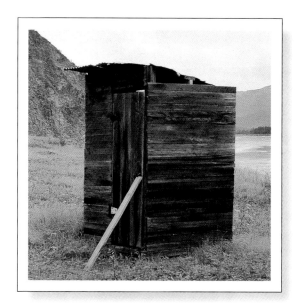

Germany

The heart on the door is the symbol for a privy in Germany as well as in some other European countries. This outhouse is in the Black Forest region.

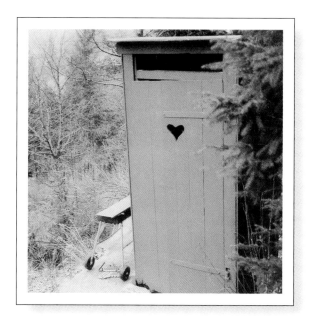

Other Names for Privies

The term "privy" is from an early Middle English word derived from the Latin *privatus,* meaning "apart" or "in secret." Here are some of the other names for outhouses:

Backhouse
Boghouse
Crapping kennel
Chapel of ease
Closet
Comfort station
Crapper
Dunnekin
Dunnick
Dunnie (Australia)
Dyke
Garden loo

Gong
Gong house
Head
Honey bucket
House of honor
Houses of Parliament
Ivy house
Jakes
Johnny
Jerry-come tumble
Joneses
Karzi
Klondike
Latrine
Lavatory
Little house
Lizzie loo
Reading room
Shit-hole
Shittush

Shooting gallery
Slack house
The gun room
The necessary house
The sociable
The thinking house
The throne room
The you-know-where
Three and more
 seaters
Thunder box
Two-seaters
Uncle John
Nessy
Netteg
Out the back
Place of easement
W.C.
Water closet
Waterloo

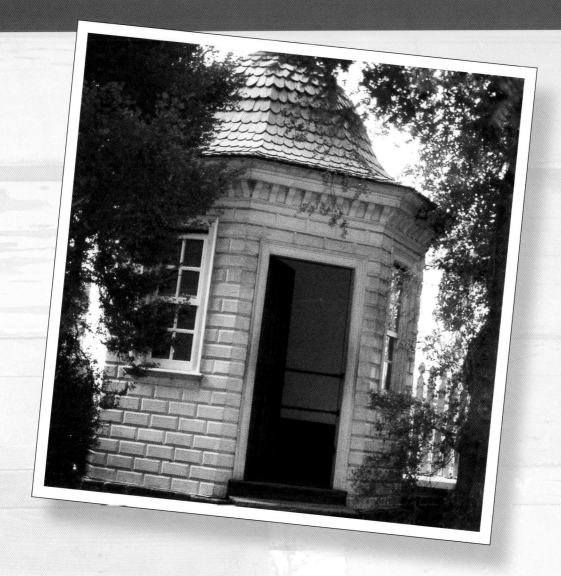

Presidential and
Celebrity Outhouses

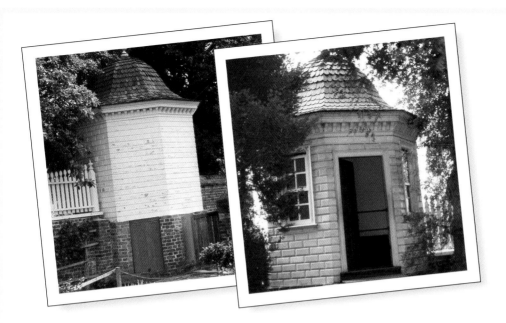

Necessary truths

At Mount Vernon, George Washington's home in Virginia, there were four outhouses, called "necessaries" by their users.

The original octagonal outhouse was constructed in the 1780s and has recently been refurbished. Its red roof is topped with an urn-shaped finial, which can be seen more easily in the photo showing the back of the outhouse. The sides are wood, rusticated to look like stone. Inside, there are beautiful mahogany seats with attached lids.

The outhouses are placed at opposite ends of the formal flower gardens. As late as the 1920s, tourists and some house staff still used the original outhouse, according to research done by King Laughlin, an intern at the estate.

The door at the back of the outhouse can be lifted for the purpose of cleaning out the box. Having a box rather than a pit for waste meant that the outhouse could easily be cleaned out.

Sanitation was a major concern for Washington at military camp and at home. In his diary he notes planting mock orange, Gilder rose, and Persian jessamine, all fragrant flowers, on the walkways to the necessaries.

The term *necessary*, used in other places besides Mount Vernon, describes an outdoor toilet that encourages the centralized collection of waste. Human waste was deposited in large wooden drawers below the seats. The drawers were removable, and the waste could be recycled as fertilizer for the gardens.

The outhouse shown in these photos is open to the public for viewing—not using, of course.

A George Washington tale told by Sherman Hines

A favorite Western outhouse story came from a United Church minister in New Denver. It concerns an outhouse that straddled a brawling Rocky Mountain creek.

One day the outhouse toppled into the creek and was swept away. Its owner accosted his young son angrily, demanding to know if he was responsible.

"No, Daddy," the son protested, "I didn't."

"Son," said the father reassuringly, "let me tell you the story of George Washington and the cherry tree. . . . Now, let me ask you again: Did you push the outhouse into the creek?"

"I cannot tell a lie," the little fellow nodded sturdily. "I did push that outhouse into the creek."

The father instantly laid hands on his son and gave him a tanning fit to make a quarterhorse whimper, while the son wailed at the unfairness of it all. "George Washington told the truth, and his father didn't give him a licking!" he protested.

"True," said the father with a grim smile, "but let me explain the difference. George Washington's father was not in the cherry tree at the time."

The Hoover moon

Herbert Hoover, the thirty-first president of the United States, was born in 1874 in West Branch, Iowa. His original outhouse is located at the Herbert Hoover National Historic Birthplace in West Branch. Bill Wilcox, the historian at the birthplace, took this photo.

Hoover was the first president born west of the Mississippi River. His father died when Herbert was six years old, and his mother died when he was eight. Although an orphan, Herbert had a pleasant boyhood and became a millionaire businessperson and a successful public official. President during the Great Depression, Hoover served only one term, defeated for re-election by Franklin Delano Roosevelt.

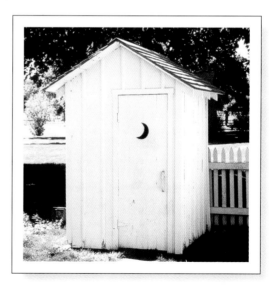

The outhouse boom

When President Franklin D. Roosevelt took office in 1933, he began to advocate general welfare programs to improve the country's infrastructure and to provide work for unemployed workers. One of the key agencies formed during his famous "Hundred Days" was the WPA, the Works Progress Administration. Among the many accomplishments of the WPA was the building of over two million "sanitary privies." The new sanitary models had concrete bases, airtight seats, and screened ventilators. People who could afford it paid five dollars cash for a ready-to-paint privy safely set on a new concrete base. Those who had no funds filled out a form and got one free. Federally trained and funded crews went out all over the countryside to rebuild any outhouses that were worth the effort and erect new ones where existing models did not measure up to federal standards.

The national benefits derived from improved sanitation and regular weekly paychecks for thirty-five thousand carpenters can never be adequately measured.

The privyless White House

Our second president, John Adams, was the first to live in the White House. He and his wife, Abigail, moved in four months before the end of his term of office. They were taken aback to learn that the house, which was still far from completion, lacked a privy! One must suppose that a potty chair with chamber pot beneath was used while an outhouse was hastily constructed. Today the White House has thirty-two bathrooms!

Thomas Jefferson's air-cooled outhouse

Archaeologists have recently found that Thomas Jefferson's outhouse was air-cooled. A tunnel that ventilated the north privy has been found at Monticello, Jefferson's home in Albemarle County, Virginia.

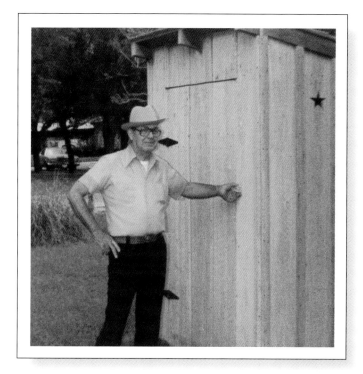

Lone Star outhouse

Lyndon Baines Johnson, thirty-sixth president of the United States, was sworn into office when President John F. Kennedy was assassinated on November 22, 1963.

Johnson was from Texas, and this outhouse is in Johnson City, his boyhood home. The star on the side of the privy could refer to Texas's nickname: the "Lone Star State." However, the star has also been used at times to distinguish a men's outhouse, so its meaning is open to debate.

The "cowboy" about to enter is not Johnson, but outhouse aficionado Homer Allison, from Bryans Road, Maryland. Crescent Moon Award–winner in 1994, this retired air force flight technician has what is possibly the largest collection of small outhouses in the country. The distinction of being an outhouse maven is not something that Homer planned. After his father built him a wooden model as a fiftieth birthday gift, he began collecting outhouses. When word of his collection got out, people across the country started sending him all kinds of little privies. His eclectic collection includes such items as a tiny outhouse carved from a lump of coal and a one-inch-high outhouse in a bottle.

Homer has photographed hundreds of privies, and he has graciously shared some of his pictures for inclusion in this book. He sincerely supports the preservation of outhouses, and plans to donate his entire collection to the Outhouse Museum in Halifax, Nova Scotia.

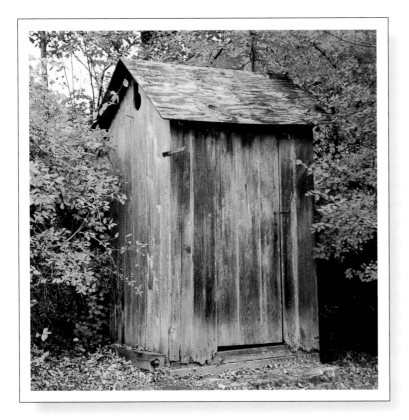

A legendary outhouse story

"Grandma" Moses, or Anna Mary Robertson, was an American primitive painter who began painting when she was seventy-eight years old. For many years, she embroidered pictures on canvas, but her fingers eventually became too stiff to work a needle, and she began painting with oils. Her gaily colored pictures of upstate New York hang in many art museums today. Grandma Moses, born in 1860, painted the countryside as she remembered it from her youth. Every morning Grandma Moses walked to the small country store in her home town of Hoosick Falls. There she would buy a newspaper and read it in the store's outhouse before walking home. Pretty soon the townfolk began calling the privy "Grandma Moses's outhouse." When Grandma Moses died at age 101, the present owner asked if she could have the outhouse. Since the store had installed indoor plumbing by then, the store's owner was delighted to have the old privy taken away. It now resides at the back of a lovely property in the southern end of Manchester, Vermont.

Too bad Grandma Moses never painted a picture of the store and "her" outhouse!

Time in an outhouse

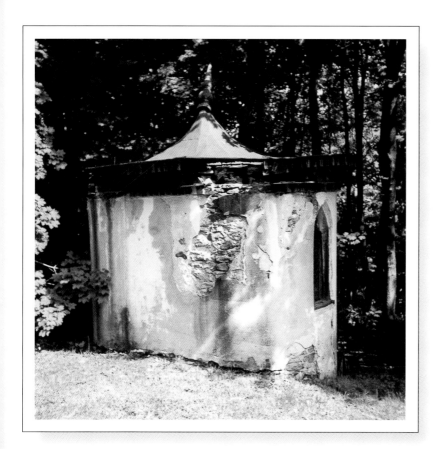

This was the outhouse of Jim Croce, songwriter in the '70s. Located in the small town of Lyndell, Pennsylvania, this very elaborate outhouse is unfortunately crumbling now. According to town folk, Croce, who lived in this region for part of his life, came here to meditate and get inspiration for songs. "Time in a Bottle" is one of Croce's best-known and loved songs.

Ideally, an interested historical group would restore this antique pre—Civil War structure to its original beauty. The arched windows and unusual roof make this outhouse architecturally unique.

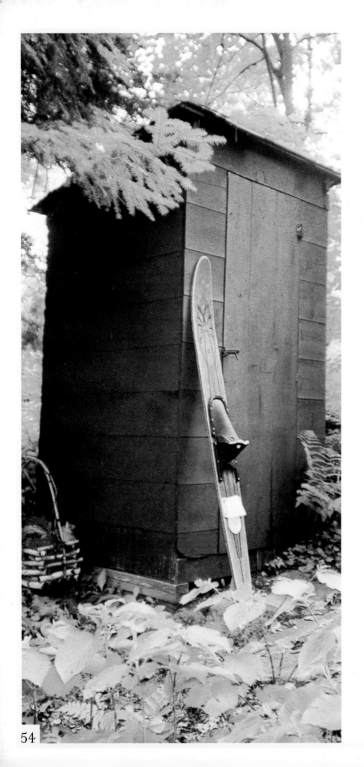

You're out!

The outhouse that baseball great Babe Ruth used as a boy was uncovered during construction of the Baltimore Orioles' new stadium at Camden Yards in Baltimore, Maryland.

One of the area's former residents was Babe's father, George Herman Ruth Senior, who operated a saloon from 1906 to 1912 in what is now center field. The Ruth family lived above the saloon, and their privy was directly behind it. The privy, found by archaeologists, was filled in and does not pose a sanitary threat in center field.

Peaceful protest

In 1990, the governor of Maryland commented that he hoped to "get rid of those shithouses on the Eastern Shore." In response, offended citizens from the Eastern Shore of Maryland made a convoy of outhouses, paraded them to Annapolis, and placed them all on the front lawn of the governor's mansion. It is rumored that the governor was pretty embarrassed.

Later, when the flurry died down, residents came out with bumper stickers that stated proudly, "I'm from the shithouse Eastern Shore."

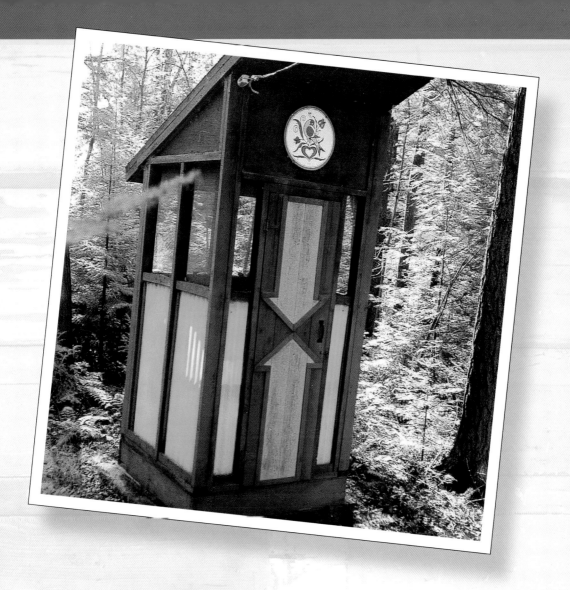

Modern Uses

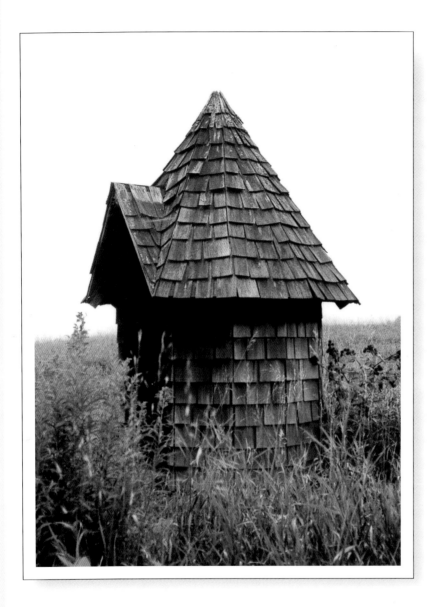

People are finding many inventive new ways to use their old outhouses.

The outhouse on the previous page, from Lake Titus, New York, is screened all the way around, which gives a nice view of the woods and lots of fresh air. (It's obviously a summer outhouse only.) Note the electricity going to the outhouse.

Some resourceful people in Vermont took the seats out of the fancy outhouse at left and moved it right up next to the road to become the children's school-bus stop. On rainy, windy, and snowy days, it makes a great shelter.

Here is what one could label a politically correct outhouse. It's a feminist one, and it looks as if it is wheelchair accessible.

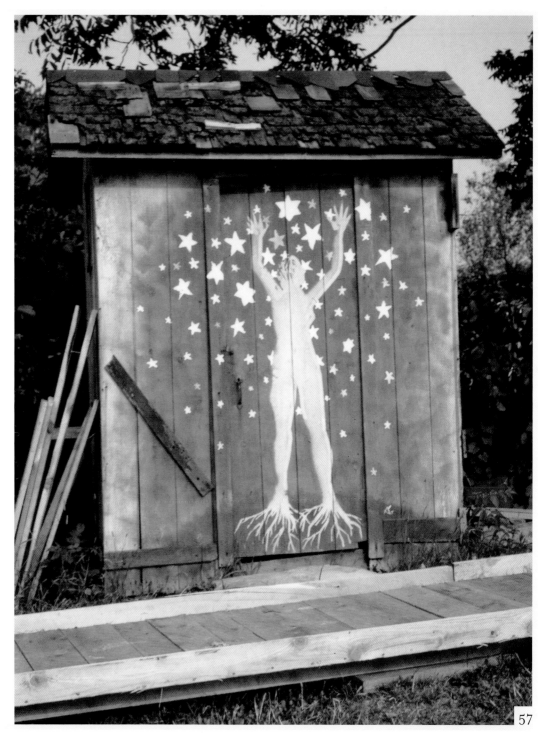

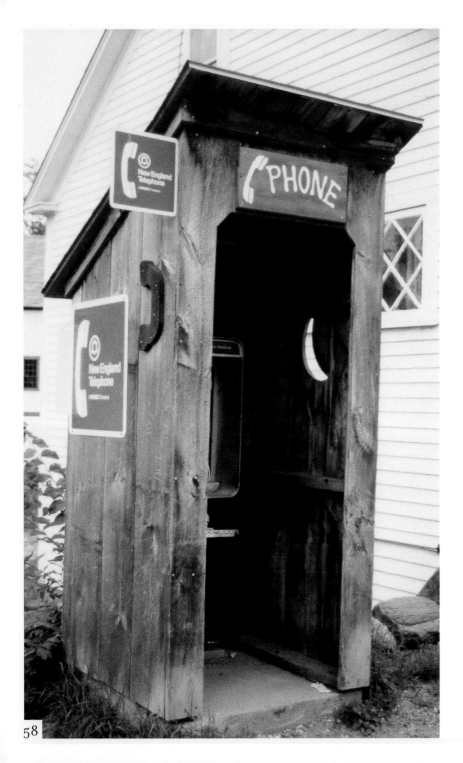

In Massachusetts some folks turned this old outhouse into a phone booth. This probably keeps a lot of people from trekking into the store only to use the phone.

There are many other uses for old outhouses. At the Shelburne Museum in Shelburne, Vermont, an attractive hexagonal privy serves as a ticket booth. Many privies have become sheds for garden tools or pool equipment. Some keep firewood safe and dry.

Some people are building new decorative outhouses for a variety of uses both outdoors and inside. Outhouses can become playhouses, saunas, guesthouses, storage places, store displays, and toy closets. People today are having a great deal of fun with little backhouses and are doing unique things with them.

Outhouses are frequently used by people who camp, hike, or hunt. If you are cross-country skiing and nature calls, a pretty little outhouse like this is a welcome sight. Nestled in the snow, this privy was found (and used) near Aspen, Colorado. The wooden bar across the front of the outhouse is a railing along a walkway that has been shoveled but cannot be seen because of the pile of snow.

An outhouse is a great pit stop if you are out snowshoeing or snowmobiling. A duplex is especially useful when there is a crowd.

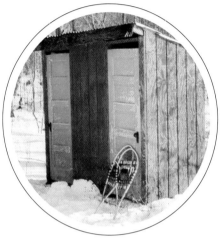

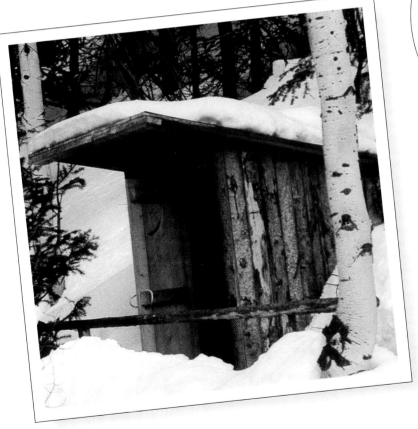

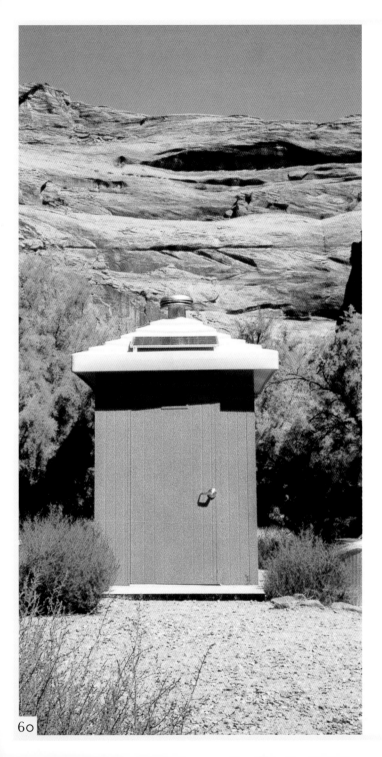

Outhouse of the '90s

 This solar-powered outhouse is located on the Colorado River near Glen Canyon Dam in Arizona. An outhouse like this costs $2,000. These outhouses, located in camping areas along the shore of the river, are large, clean, and roomy, like regular bathrooms.

Outhouse racing

These outhouses are for sport—the races. In the winter, people put outhouses on runners and race them in the snow. Anyone who wants to can enter the races.

Although you might not guess it, there are rules. There must be one person seated inside and four people pushing, for a total of no more than five people per team.

There are no existing international standards for outhouse racing, so the rules vary somewhat from state to state. It's a popular if unusual sport: There are at least twenty-three outhouse races throughout the country each year.

In Lake George, New York, outhouse races on the lake's frozen surface during the town's winter carnival have been a tradition for many years. Organizers use red Jell-O to mark the start and finish lines, because it's biodegradable and will not harm the lake's wildlife when the ice melts.

The Great Outhouse Blowout

The Great Outhouse Blowout in Gravel Switch, Kentucky, is one of outhouse racing's most impressive events. The races are held at Penn's Store, the oldest country store in America continuously owned and operated by the same family. Their outhouse is pictured below.

This race is truly the "Great Kentucky Outhouse Derby." There are cash prizes and trophies for first-, second-, and third-place winners, and trophies for the most creative outhouse and for the team that traveled the longest distance to race. In 1996, championship teams from nine U.S. states and from Canada attended. The team that took first place was the Mean Bean Speed Machine from Mountain View, Arkansas.

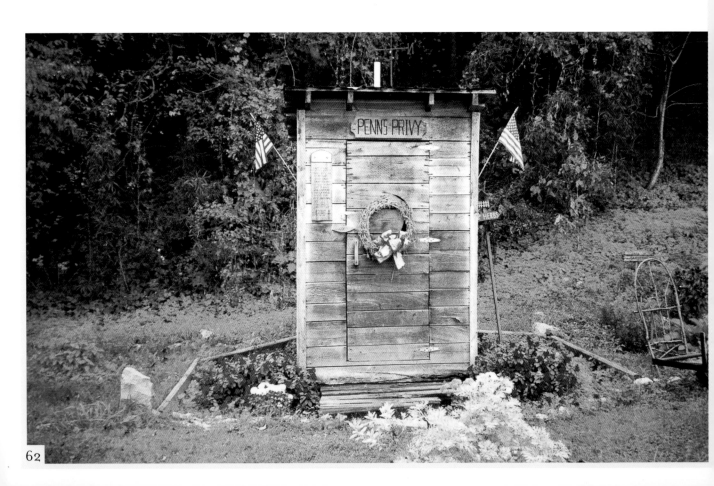

The rules for the Blowout are very specific regarding the structure of the outhouse, the team, the rider, and so on. Races are decided by elimination, run in heats of two at a time. During the race, the rider must be seated over the hole. All outhouses, of course, are human-powered: no motorized outhouses! All members of a team must dress alike. The rider must wear a helmet. No riders under twelve years of age are permitted. A grasping device for the rider to hold on to is permitted.

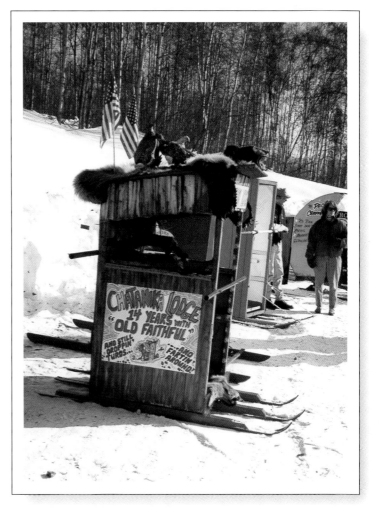

Each outhouse must have a name clearly visible on each side. No glass may be used. Racing outhouses must be at least six feet tall from the floor to the highest point of the roof.

Finally, and most important, outhouses must be structurally sound enough not to fall apart during the race!

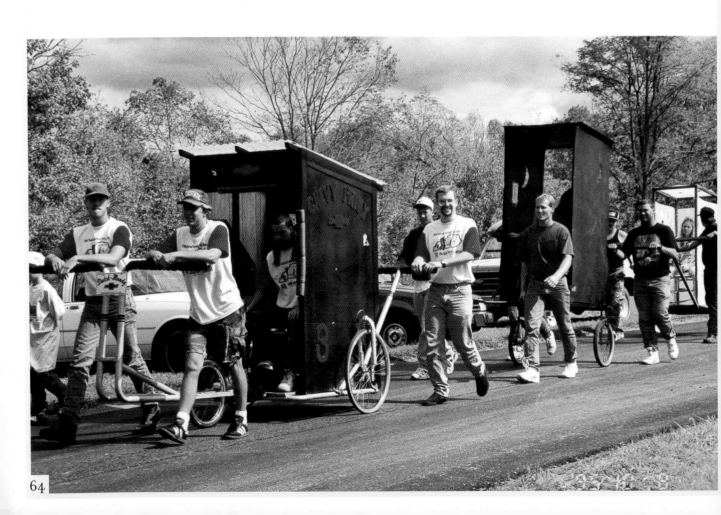

Anecdotes, Poetry, and Trivia

The following story was shared by Homer Allison:

A good friend of mine is a rather old-fashioned lady, quite elegant and delicate, especially in her language. She and her husband were planning a week-long camping trip, so she wrote to a campground for a reservation. She wanted to be sure that it was fully equipped, but didn't quite know how to ask about toilet facilities; she didn't want to write the word "toilet" in her letter. After much deliberation, she thought of the old-fashioned term "bathroom commode." But when she wrote it down, she still thought that she was being too forward. So she started over again, rewording the whole letter, this time abbreviating "bathroom commode" as "B.C.": "Does your campground have its own B.C.?" she asked.

Well, the campground owner wasn't old-fashioned at all, and when he got her letter, he couldn't figure out what the heck she was talking about. That "B.C." business really stumped him. After giving it much thought, the only expansion of "B.C." that the owner could think of was "Baptist Church," so he sat down and wrote her the following letter:

Dear Madam,

I regret very much the delay in answering your letter, but I now take pleasure in informing you that the nearest B.C. is located six miles north of our campground. It is capable of seating 250 people at a time. I will admit that it is quite a distance away if you are in the habit of going regularly.

No doubt you will be pleased to know that a great number of people take their lunches along when they go and make a day of it. They usually arrive very early and stay late. The last time my wife and I went was six months ago, and it was so crowded we had to stand up the whole time. Right now there is a supper planned to raise money for more seats. It will be held in the basement of the B.C.

I would like to say that it pains me that I am not able to go there more regularly, but it is not for lack of desire on my part. As we grow older, it seems to be more of an effort, particularly in cold weather.

If you decide to come to our campground, perhaps I could go to the B.C. with you the first time that you go, sit with you, and introduce you to all the other folks. Remember that this is a very friendly community. ☽

She bearly escaped!

(story told to the author at a trade show)

One time a bear went into our family outhouse, where-upon the door slammed shut. No one wanted to open the door and meet a charging bear. Almost immediately the angry, claustrophobic bear started banging and thumping on the walls. Soon the whole outhouse fell over and started rolling down the hill.

Fortunately, when the outhouse stopped rolling, the door was not facing the ground, and the stunned bear was able to punch the door open. She emerged somewhat dazed, while onlookers quickly scuttled to the safety of the cabin and watched from the window. The poor bear plodded off into the woods to contemplate this traumatic experience. The outhouse was so damaged we decided just to erect a new one on the original spot.

Bear bottoms

Bear-in-outhouse stories are *quite* amusing. Some friends of mine like to cross-country ski. Every winter they go to their cabin in the woods. Since the plumbing is drained every year so the pipes won't freeze, they always use the out-house.

One winter, a bear curled up on the seats of the two-holer and went to sleep for the season. What a dilemma! Determining it was best to "let the sleeping bear lie" and hoping he'd decide to leave, the family had to find another location for dropping their drawers. The bear didn't leave. All through the winter, my friends would peek through the window of the outhouse with flash-lights, and there he would be. He slept in the outhouse the entire season, unaware of the chilly inconvenience he was creating.

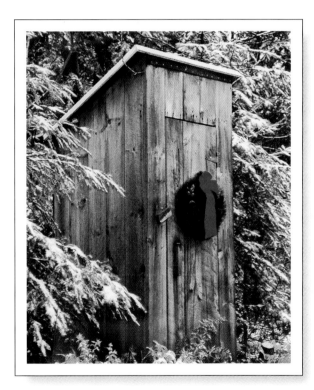

An inalienable right!

In the 1980s in Whale Beach, New Jersey, the freeholders and trustees discussed whether to allow the building of sewers in the area, which up to that point had relied on septic tanks. Because of environmental concerns, it was possible that privies could no longer be used.

An old gentleman, very much against the idea, stood up and announced to the public gathering, "I consider going to my outhouse one of my RIGHTS!"

He then added zealously, "If I don't have my privy, I'll pee off my porch!"

A 19th hole tale

One couple had an old outhouse whose roof was in dire need of repair. To take care of the problem, they took a remnant of their green indoor/outdoor carpeting and tacked it onto the roof. They then made a special flag, placed it on a pole, and set it atop the colorful roof. They named their privy the "Nineteenth Hole."

Golfer's delight

This may be the only "hole-in-one" this golfer ever gets!

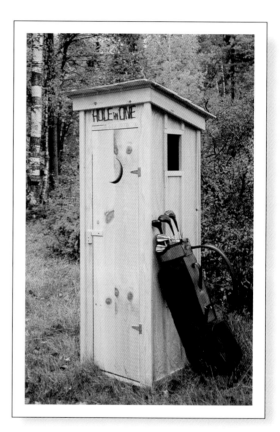

Free ad

A gentleman in New Jersey decided to buy himself a television set. When the workman came to install it, the gentleman felt the aerial would look unsightly on the house and equally unattractive on the garage. So he requested that they put the aerial on his outhouse. One night during a bad storm, the aerial came down.

When the repairman came, he restored the aerial to its proper place and then started to drive out the driveway. The owner stopped him, calling out, "What do I owe you?"

"Not a thing," the driver responded, laughing. "I'm using this job for advertising: 'We Install Anywhere'. . ."

Stinkless privy

A farmer bought an outhouse that was advertised as a "stinkless privy—guaranteed." He took the privy out to his farm, set it up, and then realized he had been duped by false advertising.

The farmer called the man who sold him the outhouse and complained: "You said this was a stinkless privy."

"Right," the seller said.

"Well, it's not," the buyer complained, "Just come out here and see for yourself."

So the seller drove to the farm, saw the outhouse, and then said to the farmer, "Well, dummy, you *used* it!"

Privy digging

Outhouse excavations have revealed priceless items that inform us about the details of life in another time. Since the outhouse was a convenient place to dump unwanted possessions, valuable objects are often unearthed when old pits are dug up. Antique-bottle collecting became very popular when colored-glass perfume, drugstore, and whiskey bottles were found. One bright green

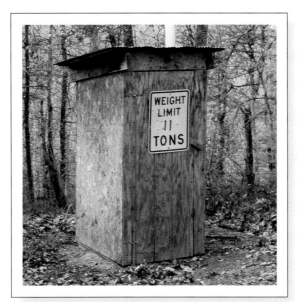

sarsaparilla bottle sold for $7,250 at a recent auction in Boston. Other items found in privy pits include sets of false teeth, shotgun shells, broken vases, soup bowls, cups, garden tools, and tin cans. Some items fell into the holes accidentally and others were placed there deliberately.

Privy excavations are generally dry and odorless. In some cases, even though the outhouse buildings have been moved to another spot or removed altogether, treasures may remain in the ground. Potential excavators need to know, however, where the outhouse was located, so that they can dig in the right place.

A National Privy Diggers Association exists, and its members communicate about their exciting discoveries in their newsletter. The name of this newsletter is *Privy*. It is available for ten dollars a year from editor Don Dzuro, 3532 Copley Road, Akron, Ohio 44321.

Privy poetry

Surprisingly, a great deal of poetry has been written about backhouses.
Most of the poems are not particularly good, but they evoke nostalgic thoughts
and provide a little humor and some insight. The outhouse poem that people
generally know best, if they know any, is "The Passing of the Backhouse,"
by James Whitcomb Riley. It is included here as part of our outhouse "education."
The reader can decide if it qualifies as a classic.

The Passing of the Backhouse

by James Whitcomb Riley

When memory keeps me company, and moves to smiles or tears,

A weather-beaten object looms through the mist of years;

Behind the house and barn it stood, a half a mile or more.

The hurrying feet a path had made, straight to the swinging door.

The architecture was a type of simple, classic art,

And in the tragedy of life it played a leading part.

And oft the passing traveler drove slow and heaved a sigh,

To see the modest hired girl slip out with glances shy.

We had our posy garden that the women loved so well.

I loved it too, but, better still, I loved the stronger smell

That filled the evening breezes so full of homely cheer,

And told the night-o'ertaken tramp that human life was near.

On lazy August afternoons it made a little bower

Delightful, where my grandsire sat and whiled away an hour,

For there the summer morning its very cares entwined,

And berry bushes reddened in the streaming soil behind.

All day fat spiders spun their webs to catch the buzzing flies

That flitted to and from the house, where Ma was baking pies.

And once a swarm of hornets bold had built a palace there,

And stung my unsuspecting aunt—I must not tell you where.

Then Father took a flaming pole—that was a happy day!

He nearly burned the building up, but the hornets left to stay.

When summer bloom began to fade, and winter to carouse,

We banked the little building with a heap of hemlock boughs.

But when the crust was on the snow and the sullen skies were gray,

In sooth, the building was no place where one could wish to stay.

We did our duties promptly—there one purpose swayed the mind.

We tarried not, nor lingered long on what we left behind.

The tortures of that icy seat could make a Spartan sob,

For needs must scrape the gooseflesh with a lacerating cob

That from a frost-encrusted nail was suspended by a string.

My father was a frugal man and wasted not a thing.

When Grandpa had to "go out back" and make this morning call,

We'd bundle up the dear old man with a muffler and a shawl.

I knew the hole on which he sat—'twas padded all around,

And once I tried to sit there—'twas all too wide I found.

My loins were all too little, and I jack-knifed there to stay.

They had to come and get me out, or I'd have passed away.

Then Father said ambition was a thing that boys should shun,

And I must use the children's hole till childhood days were done.

But still I marvel at the craft that cut the holes so true;

The baby hole, and the slender hole that fitted Sister Sue.

The dear old country landmark! I've traveled around a bit,

And in the lap of luxury has been my lot to sit.

But ere I die I'll eat the fruit of the trees I robbed of yore,

Then seek the shanty where my name is carved above the door.

I ween the old, familiar smell will soothe my jaded soul,

I'm now a man—but nonetheless, I'll try the baby hole. ☾

The Outhouse

by Willa Kabetzke

There was a little house in our backyard

Where everybody went.

A half-moon cut in either side

Was a necessary vent.

There were two holes in the seat at the back,

One larger than the other.

"Now you be careful and don't fall in,"

Was a warning from our mother.

There were some corncobs in a box,

For everyone to use:

You could take a red or white,

Whichever one you'd choose.

We saved the Sears Roebuck catalog

To put out when company came.

We children didn't understand

And thought it was a game.

If it hadn't been for the flies and wasps

Which were a miserable pest,

With the pretense of other reasons

We'd sneak out there to rest.

You'd sit there meditating

With your feet against the door;

It was only to use one at a time

But what was the other hole for?

When winter came and the snow blew in

You'd make your visit brief;

You weren't bothered with flies and wasps

But the wind blew from underneath.

The little house in our backyard

May sound crude to thee and thine

But if you'd never seen anything else

You, too, would think it fine. ☽

Potty sheriffs

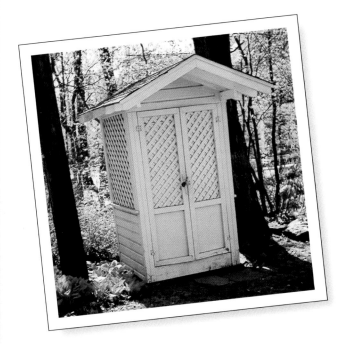

According to a book titled *Privy, Outhouse, Backhouse, John* by Wellington Durst, early jails, like other buildings at the time, had privies out back. A guard would be on duty twenty-four hours a day to escort prisoners to the "john." When a prisoner had to "go," he would call out, "Take me to de potty." These special sheriff's assistants would escort them out and bring them back. Eventually, they became known as "de potty sheriffs," which evolved into the "deputy sheriffs" we have today.

Sign posted in roadhouse privy

Please leave lid up in winter (to avoid frost) and down in summer (to keep flies out).

Return toilet paper to its hiding place under coffee can (or dog will carry it off).

Dump 3 scoops ashes down holes before leaving.

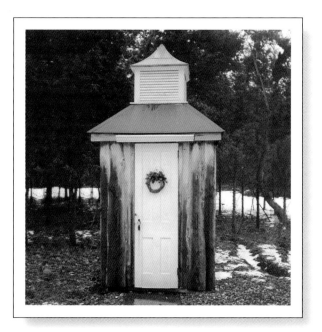

Privy trivia

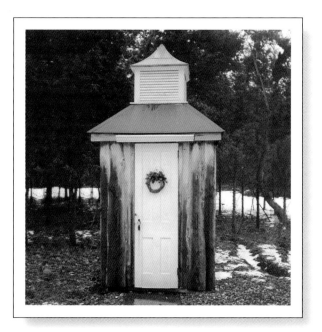 The White House had a telephone before it had indoor plumbing.

In olden days, when company came and stayed overnight, chamber pots were reserved for women and guests. Children, male or female, had to go outside, regardless of the weather.

Digging privy holes for a living was one of the few jobs in which you started at the top.

If a Great Dane or similar large dog flops down in front of the privy door, the person inside cannot get out if the door opens out!

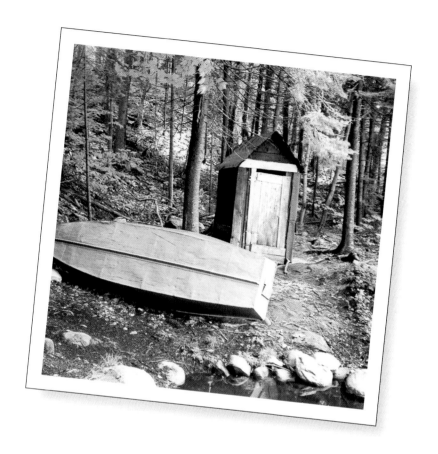

Parting thought

"How times change," the old gentleman stroked his beard and mused.
"In the old days, we used to cook inside and shit outside.
Now we cook outside and shit inside."

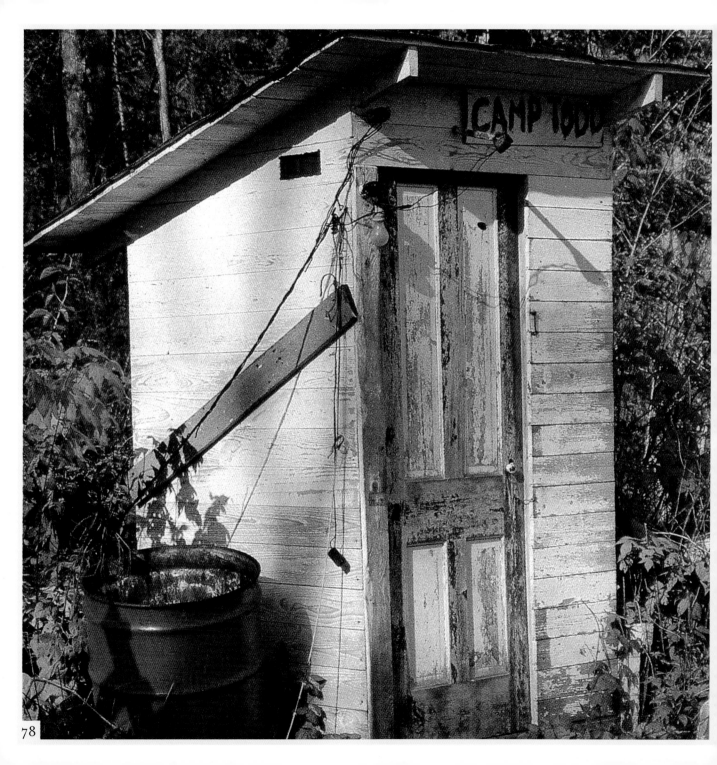

Other Books on Outhouses

Cotswold Privies by Mollie Harris, published by Salem House, 462 Boston Street, Topsfield, MA 01983, 1984.

Dinkum Dunnies by Douglass Baglin and Barbara Mullin, published by Weldon Publishing, 70 George Street, Sydney, NSW 2000, Australia, 1992.

Muddled Meanderings in an Outhouse by Bob Ross, 306 East Story, Bozeman, MT 59715, 1975.

Outhouses of the East by Sherman Hines and Ray Gay, Nimbus Publishing, Ltd., 3731 Mackintosh St., Halifax, Nova Scotia, Canada, 1978.

Privy by Janet Strombeck and Richard Strombeck, published by Sterling Publishing Co., Inc., 2 Park Ave., New York, NY 10016, 1980.

The Specialist by Charles Sale, published by The Specialist Publishing Co., 109 La Mesa Dr., Burlingame, CA 94010, 1929.

The Two-Story Outhouse by Norm Weiss, published by The Canton Printers, Ltd., P.O. Box 700, Caldwell, ID 83606, 1988.

The Vanishing American Outhouse by Ronald S. Barlow, published by Windmill Publishing Co., 2147 Windmill View Rd., El Cajon, CA 92020. This book includes a list of thirty-five books that might be of interest to readers who want more information on outhouses.

The Outhouse Preservation Society

The Outhouse Preservation Society was founded in 1996. Anyone can join this society for a one-time rate of ten dollars and will receive a framable certificate of membership. The society puts out a quarterly newsletter, available by subscription for twelve dollars (or sixteen Canadian dollars), check or money order only. To join the society or subscribe, write to:

Sherman Hines
Outhouse Preservation Society
P.O. Box 25067
Halifax, Nova Scotia
B3M 4H4 Canada

In 1997, the Outhouse Preservation Society Museum was opened in Halifax, Nova Scotia. The museum features a "Wall of Fame" of individuals who have contributed to the awareness of the outhouse through art, publishing, photography, writing, crafts, design, festivals, races, or any other appropriate medium. The first three people elected to the Wall of Fame were announced in August. They are "Chic" Sale, Bob Ross (a Montana outhouse collector who lectures and has written a couple books), and Dottie Booth.

Photo Credits

Photo Credits

(continued)

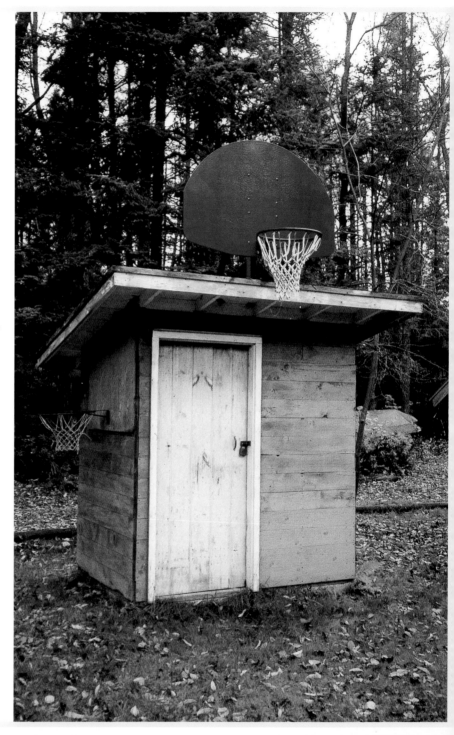

Index

Dottie Booth

In 1988, Dottie Booth snapped a photo of an old, dilapidated outhouse on family property in the Adirondacks to include in her family album. Her interest in these charming and rustic buildings grew, and she set out to document and preserve as many as she could. So many people were interested in outhouses that Dottie started a company, Nature Calls, Ltd., to market outhouse-related products such as posters, puzzles, playing cards, greeting cards, earrings, and wall stencils. Her work has raised public awareness of a rapidly disappearing part of the American landscape.

Dottie Booth was awarded the prestigious Crescent Moon Award, a prize given each year to the individual who has done the most "to preserve and promote, with dignity, the outhouse" in 1996. In 1997, she was elected to the Outhouse Wall of Fame at the Outhouse Preservation Society Museum, becoming one of only three people in history to earn that honor. Before she became an outhouse expert and entrepreneur, this elegant, designer-clad grandmother was a high-school English teacher in Abington, Pennsylvania and raised two girls and two boys. She lives in Ambler, Pennsylvania, and *Nature Calls* is her first book.

This colorful and unique 18" x 24" poster is sold by Nature Calls, Ltd.

Other products available include a 550-piece jigsaw puzzle with the image shown at right, playing cards, greeting cards, earrings, wall stencils, birdhouses, and much more. Most of these products can be found in gift shops and catalogs. If no shop near you carries items from Nature Calls, send a business-size S.A.S.E. for a retail price list and color brochure to:

Nature Calls Ltd.,
1538 Springfield Court,
Jamison, PA 18929.

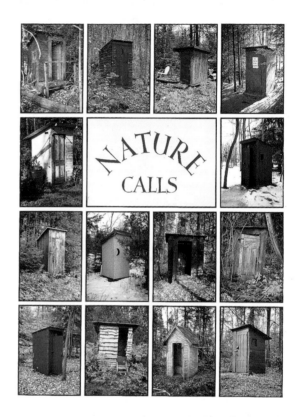